I REMEMBER

Joe Brainard

Full Court Press

Copyright© Joe Brainard 1975

Full Court Press
New York, N.Y. 10013

ISBN 0-916190-02-1 (cloth)
ISBN 0-916190-03-x (paper)

Library of Congress Cataloging in Publication Data

Brainard, Joe, 1942-
 I remember.

 Bibliography: p.
 I. Title.
PS3552.R275I16 811'.5'4 75-23153
Second printing

I REMEMBER

I remember the first time I got a letter that said "After Five Days Return To" on the envelope, and I thought that after I had kept the letter for five days I was supposed to return it to the sender.

I remember the kick I used to get going through my parents' drawers looking for rubbers. (Peacock)

I remember when polio was the worst thing in the world.

I remember pink dress shirts. And bola ties.

I remember when a kid told me that those sour clover-like leaves we used to eat (with little yellow flowers) tasted so sour because dogs peed on them. I remember that didn't stop me from eating them.

I remember the first drawing I remember doing. It was of a bride with a very long train.

I remember my first cigarette. It was a Kent. Up on a hill. In Tulsa, Oklahoma. With Ron Padgett.

I remember my first erections. I thought I had some terrible disease or something.

I remember the only time I ever saw my mother cry. I was eating apricot pie.

I remember how much I cried seeing "South Pacific" (the movie) three times.

I remember how good a glass of water can taste after a dish of ice cream.

I remember when I got a five-year pin for not missing a single morning of Sunday School for five years. (Methodist)

I remember when I went to a "come as your favorite person" party as Marilyn Monroe.

I remember one of the first things I remember. An ice box. (As opposed to a refrigerator)

I remember white margarine in a plastic bag. And a little package of orange powder. You put the orange powder in the bag with the margarine and you squeezed it all around until the margarine became yellow.

I remember how much I used to stutter.

I remember how much, in high school, I wanted to be handsome and popular.

I remember when, in high school, if you wore green and yellow on Thursday it meant that you were queer.

I remember when, in high school, I used to stuff a sock in my underwear.

I remember when I decided to be a minister. I don't remember when I decided not to be.

I remember the first time I saw television. Lucille Ball was taking ballet lessons.

I remember the day John Kennedy was shot.

I remember that for my fifth birthday all I wanted was an off-one-shoulder black satin evening gown. I got it. And I wore it to my birthday party.

I remember a dream I had recently where John Ashbery said that my Mondrian period paintings were even better than Mondrian.

I remember a dream I have had often of being able to fly. (Without an airplane)

I remember many dreams of finding gold and jewels.

I remember a little boy I used to take care of after school while his mother worked. I remember how much fun it was to punish him for being bad.

I remember a dream I used to have a lot of a beautiful red and yellow and black snake in bright green grass.

I remember St. Louis when I was very young. I remember the tattoo shop next to the bus station and the two big lions in front of the Museum of Art.

I remember an American history teacher who was always

threatening to jump out of the window if we didn't quiet down. (Second floor)

I remember my first sexual experience in a subway. Some guy (I was afraid to look at him) got a hardon and was rubbing it back and forth against my arm. I got very excited and when my stop came I hurried out and home where I tried to do an oil painting using my dick as a brush.

I remember the first time I really got drunk. I painted my hands and face green with Easter egg dye and spent the night in Pat Padgett's bath tub. She was Pat Mitchell then.

I remember another early sexual experience. At the Museum of Modern Art. In the movie theater. I don't remember the movie. First there was a knee pressed to mine. Then there was a hand on my knee. Then a hand on my crotch. Then a hand inside my pants. Inside my underwear. It was very exciting but I was afraid to look at him. He left before the movie was over and I thought he would be outside waiting for me by the print exhibition but I waited around and nobody showed any interest.

I remember when I lived in a store front next door to a meat packing house on East Sixth Street. One very fat meat packer who always ate at the same diner on the corner that I ate at followed me home and asked if he could come in and see my paintings. Once inside he instantly unzipped his blood-stained white pants and pulled out an enormous dick. He asked me to touch it and I did. As repulsive as it all was, it was exciting too, and I didn't want to hurt his feelings. But then I said I had to go out and he said, "Let's get together," and I said, "No," but he was very insistent so I said, "Yes." He was very fat and ugly and really very disgusting, so when the time came for our date I went out for a walk. But who

4

should I run into on the street but him, all dressed up and spanking clean. I felt bad that I had to tell him that I had changed my mind. He offered me money but I said no.

I remember my parents' bridge teacher. She was very fat and very butch (cropped hair) and she was a chain smoker. She prided herself on the fact that she didn't have to carry matches around. She lit each new cigarette from the old one. She lived in a little house behind a restaurant and lived to be very old.

I remember playing "doctor" in the closet.

I remember painting "I HATE TED BERRIGAN" in big black letters all over my white wall.

I remember throwing my eyeglasses into the ocean off the Staten Island ferry one black night in a fit of drama and depression.

I remember once when I made scratches on my face with my fingernails so people would ask me what happened, and I would say a cat did it, and, of course, they would know that a cat did not do it.

I remember the linoleum floors of my Dayton, Ohio room. A white puffy floral design on dark red.

I remember sack dresses.

I remember when a fish-tail dress I designed was published in "Katy Keene" comics.

I remember box suits.

I remember pill box hats.

I remember round cards.

I remember squaw dresses.

I remember big fat ties with fish on them.

I remember the first ball point pens. They skipped, and deposited little balls of ink that would accumulate on the point.

I remember rainbow pads.

I remember Aunt Cleora who lived in Hollywood. Every year for Christmas she sent my brother and me a joint present of one book.

I remember the day Frank O'Hara died. I tried to do a painting somehow especially for him. (Especially good) And it turned out awful.

I remember canasta.

I remember "How Much Is That Doggie In The Window?"

I remember butter and sugar sandwiches.

I remember Pat Boone and "Love Letters In The Sand."

I remember Teresa Brewer and "I Don't Want No Ricochet Romance."

I remember "The Tennessee Waltz."

I remember "Sixteen Tons."

I remember "The Thing."

I remember "The Hit Parade."

I remember Dorothy Collins.

I remember Dorothy Collins' teeth.

I remember when I worked in an antique-junk shop and I sold everything cheaper than I was supposed to.

I remember when I lived in Boston reading all of Dostoevsky's novels one right after the other.

I remember (Boston) pan handling on the street where all the art galleries were.

I remember collecting cigarette butts from the urns in front of The Museum of Fine Arts in Boston.

I remember planning to tear page 48 out of every book I read from the Boston Public Library, but soon losing interest.

I remember Bickford's.

I remember the day Marilyn Monroe died.

I remember the first time I met Frank O'Hara. He was walking down Second Avenue. It was a cool early Spring evening but he was wearing only a white shirt with the sleeves rolled up to his elbows. And blue jeans. And moccasins. I remember that he seemed very sissy to me. Very theatrical. Decadent. I remember that I liked him instantly.

I remember a red car coat.

I remember going to the ballet with Edwin Denby in a red car coat.

I remember learning to play bridge so I could get to know Frank O'Hara better.

I remember playing bridge with Frank O'Hara. (Mostly talk)

I remember my grade school art teacher, Mrs. Chick, who got so mad at a boy one day she dumped a bucket of water over his head.

I remember my collection of ceramic monkeys.

I remember my brother's collection of ceramic horses.

I remember when I was a "Demolay." I wish I could remember the secret handshake so I could reveal it to you.

I remember my grandfather who didn't believe in doctors. He didn't work because he had a tumor. He played cribbage all day. And wrote poems. He had very long ugly toe nails. I avoided looking at his feet as much as I could.

I remember Moley, the local freak and notorious queer. He had a very little head that grew out of his body like a mole. No one knew him, but everyone knew who he was. He was always "around."

I remember liver.

I remember Bettina Beer. (A girl) We used to go to dances

8

together. I bet she was a dike, tho it never would have oc-
curred to me at the time. She cussed a lot. And she drank and
smoked with her mother's approval. She didn't have a father.
She wore heavy blue eye shadow and she had white spots
on her arms.

I remember riding in a bus downtown one day, in Tulsa,
and a boy I knew slightly from school sat down beside me
and started asking questions like "Do you like girls?" He
was a real creep. When we got downtown (where all the
stores are) he kept following me around until finally he
talked me into going with him to his bank where he said he
had something to put in his safe-deposit box. I remember
that I didn't know what a safe-deposit box was. When we
got to the bank a bank man gave him his box and led us into
a booth with gold curtains. The boy opened up the box and
pulled out a gun. He showed it to me and I tried to be im-
pressed and then he put it back in the box and asked me if
I would unzip my pants. I said no. I remember that my knees
were shaking. After we left the bank I said that I had to go
to Brown-Dunkin's (Tulsa's largest department store) and he
said he had to go there too. To go to the bathroom. In the
men's room he tried something else (I forget exactly what)
and I ran out the door and that was that. It is very strange
that an eleven or twelve year old boy would have a safe-
deposit box. With a gun it it. He had an older sister who was
known to be "loose."

I remember Liberace.

I remember "Liberace loafers" with tassels.

I remember those bright colored nylon seersucker shirts
that you could see through.

I remember many first days of school. And that empty feeling.

I remember the clock from three to three-thirty.

I remember when girls wore cardigan sweaters backwards.

I remember when girls wore lots of can-can slips. It got so bad (so noisy) that the principal had to put a limit on how many could be worn. I believe the limit was three.

I remember thin gold chains with one little pearl hanging from them.

I remember mustard seed necklaces with a mustard seed inside a little glass ball.

I remember pony tails.

I remember when hoody boys wore their blue jeans so low that the principal had to put a limit on that too. I believe it was three inches below the navel.

I remember shirt collars turned up in back.

I remember Perry Como shirts. And Perry Como sweaters.

I remember duck-tails.

I remember Cherokee hair cuts.

I remember no belts.

I remember many Sunday afternoon dinners of fried chicken or pot roast.

I remember my first oil painting. It was of a chartreuse green field of grass with a little Italian village far away.

I remember when I tried out to be a cheerleader and didn't make it.

I remember many Septembers.

I remember one day in gym class when my name was called out I just couldn't say "here." I stuttered so badly that sometimes words just wouldn't come out of my mouth at all. I had to run around the field many times.

I remember a rather horsy-looking girl who tried to seduce me on a New York City roof. Although I got it up, I really didn't want to do anything, so I told her that I had a headache.

I remember one football player who wore very tight faded blue jeans, and the way he filled them.

I remember when I got drafted and had to go way downtown to take my physical. It was early in the morning. I had an egg for breakfast and I could feel it sitting there in my stomach. After roll call a man looked at me and ordered me to a different line than most of the boys were lined up at. (I had very long hair which was more unusual then than it is now) The line I was sent to turned out to be the line to see the head doctor. (I was going to ask to see him anyway) The doc-

tor asked me if I was queer and I said yes. Then he asked me what homosexual experiences I had had and I said none. (It was the truth) And he believed me. I didn't even have to take my clothes off.

I remember a boy who told me a dirty pickle joke. It was the first clue I had as to what sex was all about.

I remember when my father would say "Keep your hands out from under the covers" as he said goodnight. But he said it in a nice way.

I remember when I thought that if you did anything bad, policemen would put you in jail.

I remember one very cold and black night on the beach alone with Frank O'Hara. He ran into the ocean naked and it scared me to death.

I remember lightning.

I remember wild red poppies in Italy.

I remember selling blood every three months on Second Avenue.

I remember a boy I once made love with and after it was all over he asked me if I believed in God.

I remember when I thought that anything old was very valuable.

I remember "Black Beauty."

I remember when I thought that Betty Grable was beautiful.

I remember when I thought that I was a great artist.

I remember when I wanted to be rich and famous. (And I still do!)

I remember when I had a job cleaning out an old man's apartment who had died. Among his belongings was a very old photograph of a naked young boy pinned to an old pair of young boy's underwear. For many years he was the choir director at church. He had no family or relatives.

I remember a boy who worked for an undertaker after school. He was a very good tap dancer. He invited me to spend the night with him one day. His mother was divorced and somewhat of a cheap blond in appearance. I remember that his mother caught us innocently wrestling out in the yard and she got *very* mad. She told him never to do that again. I realized that something was going on that I knew nothing about. We were ten or eleven years old. I was never invited back. Years later, in high school, he caused a big scandal when a love letter he had written to another boy was found. He then quit school and worked full time for the undertaker. One day I ran into him on the street and he started telling me about a big room with lots of beds where all the undertaker employees slept. He said that each bed had a little white tent in the morning. I excused myself and said goodbye. Several hours later I figured out what he had meant. Early morning erections.

I remember when I worked in a snack bar and how much I hated people who ordered malts.

13

I remember when I worked for a department store doing fashion drawings for newspaper ads.

I remember Frank O'Hara's walk. Light and sassy. With a slight bounce and a slight twist. It was a beautiful walk. Confident. "I don't care" and sometimes "I know you are looking."

I remember four Alice Esty concerts.

I remember being Santa Claus in a school play.

I remember Beverly who had a very small cross tattooed on her arm.

I remember Miss Peabody, my grade school librarian.

I remember Miss Fly, my grade school science teacher.

I remember a very poor boy who had to wear his sister's blouses to school.

I remember Easter suits.

I remember taffeta. And the way it sounded.

I remember my collection of Nova Scotia pamphlets and travel information.

I remember my collection of "Modess because..." magazine ads.

I remember my father's collection of arrow heads.

14

I remember a 1949 red Ford convertible we once had.

I remember *The Power of Positive Thinking* by Norman Vincent Peale.

I remember "four o'clocks." (A flower that closes at four)

I remember trying to visualize my mother and father actually fucking.

I remember a cartoon of a painter painting from a naked model (back view) and on his canvas was a picture of a Parker House roll.

I remember my grandfather who lived on a farm dunking his cornbread in his buttermilk. He didn't like to talk.

I remember the outhouse and a Sears and Roebuck catalog to wipe off with.

I remember animal smells and very cold water on your face in the morning.

I remember how heavy the cornbread was.

I remember crêpe paper roses. Old calendars. And cow patties.

I remember when in grade school you gave a valentine to every person in your class in fear that someone might give you one that you didn't have one for.

I remember when dark green walls were popular.

I remember driving through the Ozarks and all the gift shops we didn't stop at.

I remember home room mothers.

I remember being a safety guard and wearing a white strap.

I remember "Hazel" in *The Saturday Evening Post*.

I remember ringworms. And name tags.

I remember always losing one glove.

I remember loafers with pennies in them.

I remember Dr. Pepper. And Royal Crown Cola.

I remember those brown fur pieces with little feet and little heads and little tails.

I remember "Suave" hair cream. (Pale peach)

I remember house shoes, plaid flannel bath robes, and "Casper" the Friendly Ghost.

I remember pop beads.

I remember "come as you are" parties. Everybody cheated.

I remember game rooms in basements.

I remember milkmen. Postmen. Guest towels. "Welcome" mats. And Avon ladies.

I remember driftwood lamps.

I remember reading once about a lady who choked to death eating a piece of steak.

I remember when fiberglass was going to solve everything.

I remember rubbing my hand under a restaurant table top and feeling all the gum.

I remember the chair I used to put my boogers behind.

I remember Pug and George and their only daughter Norma Jean who was very beautiful and died of cancer.

I remember Jim and Lucy. Jim sold insurance and Lucy taught school. Everytime we saw them they gave us a handful of plastic billfold calendars advertising insurance.

I remember Saturday night baths and Sunday morning comics.

I remember bacon and lettuce and tomato sandwiches and iced tea in the summer time.

I remember potato salad.

I remember salt on watermelon.

I remember strapless net formals in pastel colors that came down to the ankles. And carnation corsages on little short jackets.

I remember Christmas carols. And car lots.

I remember bunk beds.

I remember rummage sales. Ice cream socials. White gravy. And Hopalong Cassidy.

I remember knitted "pants" on drinking glasses.

I remember bean bag ashtrays that would stay level on irregular surfaces.

I remember shower curtains with angel fish on them.

I remember Christmas card wastebaskets.

I remember rick-rack earrings.

I remember big brass wall plates of German drinking scenes. (Made in Italy)

I remember Tab Hunter's famous pajama party.

I remember mammy cookie jars. Tomato soup. Wax fruit. And church keys.

I remember very long gloves.

I remember a purple violin bottle that hung on the wall with ivy growing out of it.

I remember very old people when I was very young. Their houses smelled funny.

I remember on Hallowe'en, one old lady you had to sing or dance or do something for before she would give you anything.

I remember chalk.

I remember when green black-boards were new.

I remember a backdrop of a brick wall I painted for a play. I painted each red brick in my hand. Afterwards it occurred to me that I could have just painted the whole thing red and put in the white lines.

I remember how much I tried to like Van Gogh. And how much, finally, I did like him. And how much, now, I can't stand him.

I remember a boy. He worked in a store. I spent a fortune buying things from him I didn't want. Then one day he wasn't there anymore.

I remember how sorry I felt for my father's sister. I thought that she was always on the verge of crying, when actually, she just had hay fever.

I remember the first erection I distinctly remember having. It was by the side of a public swimming pool. I was sunning on my back on a towel. I didn't know what to do, except turn over, so I turned over. But it wouldn't go away. I got a terrible sunburn. So bad that I had to go see a doctor. I remember how much wearing a shirt hurt.

19

I remember the organ music from "As The World Turns."

I remember white buck shoes with thick pink rubber soles.

I remember living rooms all one color.

I remember summer naps of no sleeping. And Kool-Aid.

I remember reading Van Gogh's letters to Theo.

I remember day dreams of dying and how unhappy everybody would be.

I remember day dreams of committing suicide and of the letter I would leave behind.

I remember day dreams of being a dancer and being able to leap higher than anyone thought was humanly possible.

I remember day dreams of being a singer all alone on a big stage with no scenery, just one spotlight on me, singing my heart out, and moving my audience to total tears of love and affection.

I remember driving in cars and doing landscape paintings in my head. (I still do that)

I remember the tiger lilies alongside the house. I found a dime among them once.

I remember a very little doll I lost under the front porch and never found.

I remember a man who came around with a pony and a

cowboy hat and a camera. For so much money he would take your picture on the pony wearing the hat.

I remember the sound of the ice cream man coming.

I remember once losing my nickel in the grass before he made it to my house.

I remember that life was just as serious then as it is now.

I remember "queers can't whistle."

I remember dust storms and yellow skies.

I remember rainy days through a window.

I remember salt shakers at the school cafeteria when the tops had been unscrewed.

I remember a job I once had sketching portraits of people at a coffee house. Table to table. During folk singing intermissions. By candle light.

I remember when a Negro man asked me to paint a big Christmas picture to hang in his picture window at Christmas and I painted a white madonna and child.

I remember one year in school our principal was Mr. Black and my art teacher was Mrs. Black. (They were not married)

I remember a story my mother telling of an old lady who had a china cabinet filled with beautiful antique china and stuff. One day a tornado came and knocked the cabinet over and to the floor but nothing in it got broken. Many years later

she died and in her will she left my father a milk glass candy dish in the shape of a fish. (It had been in the cabinet) At any rate, when the candy dish arrived it was all broken into many pieces. But my father glued it back together again.

I remember a big black rubber thing going over my mouth and nose just before I had my tonsils taken out. After my tonsils were taken out I remember how my throat felt eating vanilla ice cream.

I remember one morning the milkman handed me a camera. I never did understand exactly why. I'm sure it had something to do with a contest tho.

I remember Marilyn Monroe's softness in "The Misfits."

I remember the gasoline station in the snow in "The Umbrellas of Cherbourg."

I remember when hoop skirts had a miniature revival.

I remember waking up somewhere once and there was a horse staring me in the face.

I remember sitting on top of a horse and how high up it was.

I remember a chameleon I got at the circus that was supposed to change colors each time he was on a different color, but he only changed from green to brown and from brown back to green. And it was a rather brown-green at that.

I remember never winning at bingo, tho I'm sure I must have.

I remember a little girl who had a white rabbit coat and hat and muff. Actually, I don't remember the little girl. I remember the coat and the hat and the muff.

I remember radio ball game sounds coming from the garage on Saturday afternoons.

I remember hearing stories about why Johnny Ray was such an unhappy person but I can't remember what the stories were.

I remember the rumor that Dinah Shore was half Negro but that her mother never told her and so when she had a light brown baby she sued her mother for not telling her. (That she was half Negro)

I remember my father in black-face. As an end man in a minstrel show.

I remember my father in a tutu. As a ballerina dancer in a variety show at church.

I remember Anne Kepler. She played the flute. I remember her straight shoulders. I remember her large eyes. Her slightly roman nose. And her full lips. I remember an oil painting I did of her playing the flute. Several years ago she died in a fire giving a flute concert at a children's home in Brooklyn. All the children were saved. There was something about her like white marble.

I remember people who went to church only on Easter and Christmas.

I remember cinnamon toothpicks.

I remember cherry Cokes.

I remember pastel colored rocks that grew in water.

I remember drive-in onion rings.

I remember that the minister's son was wild.

I remember pearlized plastic toilet seats.

I remember a little boy whose father didn't believe in dancing and mixed swimming.

I remember when I told Kenward Elmslie that I could play tennis. He was looking for someone to play with and I wanted to get to know him better. I couldn't even hit the ball but I did get to know him better.

I remember when I didn't really believe in Santa Claus but I wanted to so badly that I did.

I remember when the Pepsi-Cola Company was on its last leg.

I remember when Negroes had to sit at the back of the bus.

I remember pink lemonade.

I remember paper doll twins.

I remember puffy pastel sweaters. (Angora)

I remember drinking glasses with girls on them wearing bathing suits but when you filled them up they were naked.

I remember dark red fingernail polish almost black.

I remember that cherries were too expensive.

I remember a drunk man in a tuxedo in a bar who wanted Ron Padgett and me to go home with him but we said no and he gave us all his money.

I remember how many other magazines I had to buy in order to buy one physique magazine.

I remember a climbing red rose bush all over the garage. When rose time came it was practically solid red.

I remember a little boy down the street. Sometimes I would hide one of his toys inside my underwear and make him reach in for it.

I remember how unsexy swimming naked in gym class was.

I remember that "Negro men have giant cocks."

I remember that "Chinese men have little cocks."

I remember a girl in school one day who, just out of the blue, went into a long spiel all about how difficult it was to wash her brother's pants because he didn't wear underwear.

I remember slipping underwear into the washer at the last minute (wet dreams) when my mother wasn't looking.

I remember a giant gold man taller than most buildings at "The Tulsa Oil Show."

I remember trying to convince my parents that not raking leaves was good for the grass.

I remember that *I* liked dandelions all over the yard.

I remember that my father scratched his balls a lot.

I remember very thin belts.

I remember James Dean and his red nylon jacket.

I remember thinking how embarrassing it must be for men in Scotland to have to wear skirts.

I remember when Scotch tape wasn't very transparent.

I remember how little your dick is, getting out of a wet bathing suit.

I remember saying "thank you" when the occasion doesn't call for it.

I remember shaking big hands.

I remember saying "thank you" in reply to "thank you" and then the other person doesn't know what to say.

I remember getting erections in school and the bell rings and how handy zipper notebooks were.

I remember zipper notebooks. I remember that girls hugged them to their breasts and that boys carried them loosely at one side.

I remember trying to make a new zipper notebook look old.

I remember never thinking Ann Miller beautiful.

I remember thinking that my mother and father were ugly naked.

I remember when I found a photograph of a woman naked from the waist up with very big tits and I showed it to a boy at school and he told the teacher about it and the teacher asked to see it and I showed it to her and she asked me where I got it and I said that I found it on the street. Nothing happened after that.

I remember peanut butter and banana sandwiches.

I remember jewelled sweaters with fur collars open to the waist.

I remember the Box Car Twins.

I remember not looking at crippled people.

I remember Mantovani and his (100 Strings?).

I remember a woman with not much neck. On her large feet she always wore bright colored suede platform shoes. My mother said they were very expensive.

I remember corrugated ribbon that you ran across the blade of a pair of scissors and it curled all up.

I remember that I never cried in front of other people.

I remember how embarrassed I was when other children cried.

I remember the first art award I ever won. In grade school. It was a painting of a nativity scene. I remember a very large star in the sky. It won a blue ribbon at the fair.

I remember when I started smoking I wrote my parents a letter and told them so. The letter was never mentioned and I continued to smoke.

I remember how good wet dreams were.

I remember a roller coaster that went out over a lake.

I remember visions (when in bed but not asleep yet) of very big objects becoming very small and of very small objects becoming very big.

I remember seeing colors and designs by closing my eyes very tightly.

I remember Montgomery Clift in "A Place In The Sun."

I remember bright colored aluminum drinking glasses.

I remember "The Swing" dance.

I remember "The Chicken."

I remember "The Bop."

I remember monkeys who did modern paintings and won prizes.

I remember "I like to be able to tell what things are."

I remember "Any little kid could do that."

I remember "Well, it may be good but I just don't under-
stand it."

I remember "I like the colors."

I remember "You couldn't give it to me."

I remember "It's interesting."

I remember Bermuda shorts and knee lengths socks.

I remember the first time I saw myself in a full length
mirror wearing Bermuda shorts. I never wore them again.

I remember playing doctor with Joyce Vantries. I remem-
ber her soft white belly. Her large navel. And her little slit
between her legs. I remember rubbing my ear against it.

I remember Lois Lane. And Della Street.

I remember jerking off to sexual fantasies of Troy Donahue
with a dark tan in a white bathing suit down by the ocean.
(From a movie with Sandra Dee)

I remember sexual fantasies of making it with a stranger
in the woods.

I remember sexual fantasies in white tile shower rooms.
Hard and slippery. Abstract and steamy. Wet body to wet
body. Slippery, fast, and squeaky.

I remember sexual fantasies of seducing young country boys (but old enough): Pale and blond and eager.

I remember jerking off to sexual fantasies involving John Kerr. And Montgomery Clift.

I remember a very wet dream with J. J. Mitchell in a boat.

I remember jerking off to visions of body details.

I remember navels. Torso muscles. Hands. Arms with large veins. Small feet. (I like small feet) And muscular legs.

I remember underarms where the flesh is softer and whiter.

I remember blond heads. White teeth. Thick necks. And certain smiles.

I remember underwear. (I like underwear) And socks.

I remember the wrinkles and creases of fabric being worn.

I remember tight white T-shirts and the gather of wrinkles from under the arms.

I remember sexual fantasies of old faded worn and torn blue jeans and the small areas of flesh revealed. I especially remember torn back pockets with a triangle of soft white bottom showing.

I remember a not very pleasant sexual dream involving Kenward Elmslie's dog Whippoorwill.

30

I remember green Easter egg grass.

I remember never really believing in the Easter bunny. Or the sandman. Or the tooth fairy.

I remember bright colored baby chickens. (Dyed) They died very fast. Or ran away. Or something. I just remember that shortly after Easter they disappeared.

I remember farts that smell like old eggs.

I remember one very hot summer day I put ice cubes in my aquarium and all the fish died.

I remember dreams of walking down the street and suddenly realizing that I have no clothes on.

I remember a big black cat named Midnight who got so old and grouchy that my parents had him put to sleep.

I remember making a cross of two sticks for something my brother and me buried. It might have been a cat but I think it was a bug or something.

I remember regretting things I didn't do.

I remember wishing I knew then what I know now.

I remember peach colored evenings just before dark.

I remember "lavender past." (He has a . . .)

I remember Greyhound buses at night.

I remember wondering what the bus driver is thinking about.

I remember empty towns. Green tinted windows. And neon signs just as they go off.

I remember (I think) lavender tinted windows on one bus.

I remember tricycles turned over on front lawns. Snow ball bushes. And plastic duck families.

I remember glimpses of activity in orange windows at night.

I remember little cows.

I remember that there is always one soldier on every bus.

I remember small ugly modern churches.

I remember that I can never remember how bathroom doors in buses open.

I remember donuts and coffee. Stools. Pasted-over prices. And gray people.

I remember wondering if the person sitting across from me is queer.

I remember rainbow colored grease spots on the pavement after a rain.

I remember undressing people (in my head) walking down the street.

I remember, in Tulsa, a red sidewalk that sparkled.

I remember being hit on the head by birdshit two times.

I remember how exciting a glimpse of a naked person in a window is even if you don't really see anything.

I remember "Autumn Leaves."

I remember a very pretty German girl who just didn't smell good.

I remember that Eskimos kiss with their noses. (?)

I remember that the only friends my parents had who owned a swimming pool also owned a funeral parlor.

I remember laundromats at night all lit up with nobody in them.

I remember a very clean Catholic book-gift shop with practically nothing in it to buy.

I remember rearranging boxes of candy so it would look like not so much was missing.

I remember brown and white shoes with little decorative holes cut out of them.

I remember certain group gatherings that are hard to get up and leave from.

I remember alligators and quicksand in jungle movies. (Pretty scary)

I remember opening jars that nobody else could open.

I remember making home-made ice cream.

I remember that I liked store bought ice cream better.

I remember hospital supply store windows.

I remember stories of what hot dogs are made of.

I remember Davy Crockett hats. And Davy Crockett just about everything else.

I remember not understanding why people on the other side of the world didn't fall off.

I remember wondering why, if Jesus could cure sick people, why He didn't cure all sick people.

I remember wondering why God didn't use his powers more to end wars and stop polio. And stuff like that.

I remember "Love Me Tender."

I remember trying to realize how big the world really is.

I remember trying to figure out what it's all about. (Life)

I remember catching lightningbugs and putting them in a jar with holes in the lid and then letting them out the next day.

I remember making clover blossom chains.

I remember in Boston a portrait of Isabella Gardner by Whistler.

I remember in Tulsa my first one-man show of brush and ink drawings of old fashioned children. They were so intricate and fine that nobody could believe that I did them with a brush. But I did.

I remember winning a Peter Pan Coloring Contest and getting a free pass to the movies for a year.

I remember Bunny Van Valkenburg. She had a little nose. A low hairline. And two big front teeth. She was my girl friend for several years when we were very young. Later on, in high school, she turned into quite a sex-pot.

I remember Bunny Van Valkenburg's mother Betty. She was short and dumpy and bubbly and she wore giant earrings. Once she wallpapered her kitchen floor with wallpaper. Then shellacked it.

I remember Bunny Van Valkenburg's father Doc. He was our family doctor. I remember him telling of a patient he had who got poison ivy inside his body. The man was in total misery but it healed very fast because there was no way that he could scratch it.

I remember that the Van Valkenburgs had more money than we did.

I remember in grade school tying a mirror to your shoe and casually slipping it between a girl's legs during conversation. Other boys did that. I didn't.

I remember eating tunnels and cities out of watermelon.

I remember how sad "The Jane Froman Story" was.

I remember George Evelyn who had a red and white face

because of an explosion he was in once. And his wife Jane who wore green a lot and laughed very loud. I remember their only son George Junior who was my age. He was very fat and very wild. But I hear that he settled down, got married, and is active in church.

I remember the first time I saw Elvis Presley. It was on the "Ed Sullivan Show."

I remember "Blue Suede Shoes." And I remember having a pair.

I remember felt skirts with cut-out felt poodles on them. Sometimes their collars were jeweled.

I remember bright orange canned peaches.

I remember jeweled bottle openers.

I remember the horse lady at the fair. She didn't look like a horse at all.

I remember pillow fights.

I remember being surprised at how yellow and how red autumn *really* is.

I remember chain letters.

I remember Peter Pan collars.

I remember mistletoe.

I remember Judy Garland singing "Have Yourself A Merry Little Christmas" (so sad) in "Meet Me In St. Louis."

I remember Judy Garland's red shoes in "The Wizard Of Oz."

I remember Christmas tree lights reflected on the ceiling.

I remember Christmas cards arriving from people my parents forgot to send Christmas cards to.

I remember the Millers who lived next door. Mrs. Miller was an Indian and Mr. Miller was a radio ham. They had five children and a very little house. There was always junk all over their yard. And inside the house too. Their living room was completely taken up by a big green ping pong table.

I remember taking out the garbage.

I remember "the Ritz" movie theater. It was full of statues and the ceiling was like a sky at night with twinkling stars.

I remember wax paper.

I remember what-not shelves of two overlapping squares. One higher than the other.

I remember ballerina figurines from Japan with real net-like tutus.

I remember chambray work shirts. And dirty tennis shoes with no socks.

I remember wood carvings of funny doctors.

I remember the "T-zone." (Camel cigarettes)

I remember big brown radios.

I remember long skinny colored glass decanters from Italy.

I remember fishnet.

I remember board and brick book shelves.

I remember bongo drums.

I remember candles in wine bottles.

I remember one brick wall and three white walls.

I remember the first time I saw the ocean. I jumped right in, and it swept me right under, down, and back to shore again.

I remember being disappointed in Europe that I didn't *feel* any different.

I remember when Ron Padgett and I first arrived in New York City we told a cab driver to take us to the Village. He said, "Where?" And we said, "To the Village." He said, "But where in the Village?" And we said, "Anywhere." He took us to Sixth Avenue and 8th Street. I was pretty disappointed. I thought that the Village would be like a real village. Like my vision of Europe.

I remember putting on sun tan oil and having the sun go away.

I remember Dorothy Kilgallen's face.

I remember toreador pants.

I remember a babyblue matching skirt and sweater that Suzy Barnes always wore. She was interested in science. All over her walls were advertising matchbook covers hanging on rolls of string. She had a great stamp collection too. Her mother and father were both over six feet tall. They belonged to a club for people over six feet tall only.

I remember doing other things with straws besides drinking through them.

I remember an ice cream parlor in Tulsa that had a thing called a pig's dinner. It was like a very big banana split in a wooden dish made to look like a pig's trough. If you ate it all they gave you a certificate saying that you ate it all.

I remember after people are gone thinking of things I should have said but didn't.

I remember how much rock and roll music can hurt. It can be so free and sexy when you are not.

I remember Royla Cochran. She lived in an attic and made long skinny people out of wax. She was married to a poet with only one arm until he died. He died, she said, from a pain in the arm that wasn't there.

I remember eating alone in restaurants a lot because of some sort of perverse pleasure I don't want to think about right now. (Because I still do it)

I remember the first escalator in Tulsa. In a bank. I remember riding up and down it. And up and down it.

I remember drawing pictures in church on pledge envelopes and programs.

I remember having a casual chat with God every night and usually falling asleep before I said, "Amen."

I remember the great girl-love of my life. We were both the same age but she was too old and I was too young. Her name was Marilyn Mounts. She had a small and somehow very vulnerable neck. It was a long thin neck, but soft. It looked like it would break very easily.

I remember Sen-Sen: Little black squares that taste like soap.

I remember that little jerk you give just before you fall asleep. Like falling.

I remember when I won a scholarship to the Dayton, Ohio Art Institute and I didn't like it but I didn't want to hurt their feelings by just quitting so I told them that my father was dying of cancer.

I remember in Dayton, Ohio the art fair in the park where they made me take down all my naked self-portraits.

I remember a middle-aged lady who ran an antique shop in the Village. She asked me to come over and fix her bathroom late at night but she wouldn't say what was wrong with it. I said yes because saying no has always been difficult for me. But the night I was to go I just didn't go. The antique shop isn't there anymore.

I remember how disappointing going to bed with one of the most beautiful boys I have ever seen was.

I remember jumping off the front porch head first onto the corner of a brick. I remember being able to see nothing but gushing red blood. This is one of the first things I remember. And I have a scar to prove it.

I remember white bread and tearing off the crust and rolling the middle part up into a ball and eating it.

I remember toe jams. I never ate toe jams but I remember kids that did. I *do* remember eating snot. It tasted pretty good.

I remember dingle berries.

I remember rings around your neck. (Dirt)

I remember thinking once that flushing away pee might be a big waste. I remember thinking that pee is probably good for something and that if one could just discover what it was good for one could make a mint.

I remember staying in the bath tub too long and having wrinkled toes and fingers.

I remember "that" feeling, cleaning out your navel.

I remember pouring out a glass of water (I was a fountain) in a front porch musical production of "Strolling Through The Park One Day."

I remember tying two bicycles together for a production number of "Bicycle Built For Two."

I remember a store we had where we bought stuff at the five and ten and then re-sold the stuff for a penny or two more than it cost. And then with the money we bought more stuff. Etc. We ended up by making several dollars clear.

I remember paying a dime and getting a red paper poppy made by people in wheelchairs.

I remember little red feathers. That, I think, was the Red Cross.

I remember making tents on the front porch on rainy days.

I remember wanting to sleep out in the back yard and being kidded about how I wouldn't last the night and sleeping outside and not lasting the night.

I remember a story about my mother finding a rat walking all over my brother's face while he was sleeping. Before I was born.

I remember a story about how when I was very young I got a pair of scissors and cut all my curls off because a boy down the street told me that curls were sissy.

I remember when I was very young saying "hubba-hubba" whenever I saw a red headed lady because my father liked redheads and it was always good for a laugh.

I remember that my mother's favorite movie star was June Allyson.

I remember that my father's favorite movie star was Rita Hayworth.

I remember being Joseph in a live nativity scene (that didn't move) in a park. You just had to stand there for half an hour and then another Joseph came and you had a cup of hot chocolate until your turn came again.

I remember taking a test to see which musical instrument I would be best suited for. They said it was the clarinet so I got a clarinet and took lessons but I was terrible at it so I stopped.

I remember trying to convince Ron Padgett that I didn't believe in God anymore but he wouldn't believe me. We were in the back of a truck. I don't remember why.

I remember buying things that were too expensive because I didn't like to ask the price of things.

I remember a spooky job I had once cleaning up a dentist's office after everyone had gone home. I had my own key. The only part I liked was straightening up the magazines in the waiting room. I saved it as the last thing to do.

I remember "Revlon." And that ex-Miss America lady.

I remember wondering why, since I am queer, I wouldn't rather be a girl.

I remember trying to devise something with a wet sponge in a glass to jerk off into but it didn't quite work out.

I remember trying to blow myself once but I couldn't quite do it.

I remember optical illusions when laying face down and arms folded over my head in the sun of big eyebrows (magnified) and of two overlapping noses. (Also magnified)

I remember getting rid of everything I owned on two occasions.

I remember wondering if my older brother is queer too.

I remember that I was a terrible coin collector because I was always spending them.

I remember gray-silver pennies. (Where did they go?)

I remember "Ace" combs.

I remember "Dixie" drinking cups. And "Bond" bread.

I remember the "Breck" shampoo ladies.

I remember the skinny guy who gets sand kicked in his face in body-building advertisements.

I remember blonde women who get so much sun you can't see them.

44

I remember being disappointed the first time I got my teeth cleaned that they didn't turn out real white.

I remember trying to visualize what my insides looked like.

I remember people who like to look you straight in the eye for a long time as though you have some sort of mutual understanding about something.

I remember *almost* sending away for body building courses many times.

I remember bright orange light coming into rooms in the late afternoon. Horizontally.

I remember the "$64,000 Question" scandal.

I remember that woman who was always opening refrigerators.

I remember light blue morning glories on the fence in the morning. Morning glories always surprise me. I never really expect them to be there.

I remember miniature loaves of real bread the Bond Bread Company gave you when you went on a tour of their plant.

I remember stories about bodies being chopped up and disposed of in garbage disposals.

I remember stories about razor blades being hidden in apples at Halloween. And pins and needles in popcorn balls.

I remember stories about what goes on in restaurant kitchens. Like spitting in the soup. And jerking off in the salad.

I remember a story about a couple who owned a diner. The husband murdered his wife and ground her up in the hamburger meat. Then one day a man was eating a hamburger at the diner and he came across a piece of her fingernail. That's how the husband got caught.

I remember that Lana Turner was discovered sipping a soda in a drugstore.

I remember that Rock Hudson was a truck driver.

I remember that Betty Grable didn't smoke or drink or go to Hollywood parties.

I remember a ringworm epidemic and being scared to death that I would get it. If you got it they shaved off your hair and put green stuff all over your scalp.

I remember drinking fountains that start out real low and when you put your face down they spurt way up into your nose.

I remember my grade school librarian Miss Peabody. At the beginning of each class we had to all say in unison "Good morning Miss Peabody!" Only instead we said "Good morning Miss *Pee*-body!" I guess she decided to ignore this because she never said anything about it. She was very tall and very thin and there was always a ribbon or a scarf tied around her head from which bubbled lots of silver-gray curls.

I remember in gym class during baseball season certain ways of avoiding having to go to bat.

I remember on "free day" in gym class usually picking stilts.

I remember "Your shirt tail's on fire!" and then you yank it out and say "Now it's out!"

I remember "Your front door is open." Or maybe it was "Barn door." Or both.

I remember "bathroom stationery."

I remember being embarrassed to buy toilet paper at the corner store unless there were several other things to buy too.

I remember a joke about Tom, Dick, and Harry that ended up, "Tom's dick is hairy."

I remember "sick" jokes.

I remember Mary Anne jokes.

I remember "Mommy, Mommy, I don't like my little brother." "Shut up, Mary Anne, and eat what I tell you to!" (That's a Mary Anne joke)

I remember once having to take a pee sample to the doctor and how yellow and warm it was in a jar.

I remember socks that won't stay up.

I remember the little boy with the very deep voice in "Gentlemen Prefer Blondes." (Like a frog)

I remember a red velvet swing in a movie called "The Red Velvet Swing."

I remember having to pull down my pants once to show the doctor my dick. It was all red and swollen. A solid mass of chigger bites. (Pretty embarrassing)

I remember wondering why anyone would want to be a doctor, and I still do.

I remember always getting in trouble for giving everything away.

I remember *really* getting in trouble once for trading a lot of expensive toys for a rock and a pocket knife.

I remember a girl in grade school who had shiny legs that were cracked like a Chinese vase.

I remember burying some things in the dirt once thinking that someday someone would find them and it would be a great surprise but a few days later I dug them up myself.

I remember when Lenox China had an essay contest in connection with a local store that carried Lenox China. Whoever wrote the best essay about Lenox China was supposed to get a free place setting of their choice but I don't remember anyone winning. I think somehow the contest got dropped.

I remember square dancing and "The Texas Star."

I remember an old royal blue taffeta formal my little sister had for playing dress-up in and *I* remember dressing up in it.

I remember "hand-me-downs."

I remember pig-latin.

I remember reading twelve books every summer so as to get a "certificate" from the local library. I didn't give a shit about reading but I loved getting certificates. I remember picking books with big print and lots of pictures.

I remember earaches. Cotton. And hot oil.

I remember not liking mashed potatoes if there was a single lump in them.

I remember "Howdy Doody" and "Queen for a Day."

I remember taking an I.Q. test and coming out below average. (I've never told anybody that before)

I remember pedal-pushers.

I remember thinking about whether or not one should kill flies.

I remember giving myself two or three wishes and trying to figure out what they would be. (Like a million dollars, no more polio, and world peace)

I remember locker rooms. And locker room smells.

I remember a dark green cement floor covered with wet footprints going in all different directions. Thin white towels. And not "looking around" too much.

I remember one boy with an absolutely enormous cock. And he knew it. He was always last to get dressed. (Putting his socks on first)

I remember that I put everything else on before I put my socks on.

I remember that Gene Kelly had no basket.

I remember the scandal Jane Russell's costume in "The French Line" caused.

I remember a color foldout pinup picture of Jane Russell lounging in a pile of straw in "Esquire" magazine with one bare shoulder.

I remember that Betty Grable's legs were insured for a million dollars.

I remember a picture of Jayne Mansfield sitting in a pink Cadillac with two enormous pink poodles.

I remember how long Oscar Levant's piano numbers were.

I remember (I think) a candy bar called "Big Dick."

I remember "Payday" candy bars and eating the peanuts off first and then eating the center part.

I remember a big brown chewy thing on a stick that you could lick down to a very sharp point.

I remember a *very* chewy kind of candy sold mostly at movie theatres. (Chocolate covered caramel pieces of candy in a yellow box) They stuck to your teeth. *So* chewy one box would last for a whole movie.

I remember how boring newsreels were.

I remember a boy named Henry who was said to have poured a mixture of orange pop and popcorn off the balcony of the "Ritz" movie theatre as he made gagging sounds.

I remember trying to imagine certain people going to the bathroom.

I remember someone telling me that if you farted on a lit match it would make a big blue flame.

I remember wondering if girls fart too.

I remember marbles.

I remember *having* marbles more than I remember *playing* marbles.

I remember playing hop-scotch without ever really knowing the rules.

I remember a plate that hung on the wall above the T.V. set that said, "God Bless Our Mortgaged Home."

I remember light green notebook paper. (Better for your eyes than white)

I remember the school cafeteria. Silverware clanking noises. Stacks of chipped brown trays. Little cartons of

milk. And red jello cut up into cubes.

I remember that girls who worked in the school cafeteria had to wear hair nets.

I remember fruit cocktail.

I remember chicken noodle soup when you are sick.

I remember when I was very young a department store where when you bought something the saleslady put your money in a tubular container that traveled through a series of pipes. Then the container returned with a "dong" and your change.

I remember finding $21 in a black coin purse in a big department store in St. Louis. I reported having found it but since nobody reported losing it I got to keep it.

I remember that a good way to catch a cold is to walk around barefooted. To not get enough sleep. And to go outside with wet hair.

I remember "colored town." (Tulsa)

I remember that "Negroes who drive around in big shiny Cadillacs usually live in broken down shacks."

I remember when Negroes first started moving into white neighborhoods. How everyone got scared because if a Negro moved into your neighborhood the value of your property would go way down.

I remember bubble gum. Blowing big bubbles. And trying to get bubble gum out of my hair.

I remember eating dried airplane glue off my fingers. (yum-yum)

I remember the smell (loved it) of fingernail polish.

I remember black heels on new shoes that mark up floors.

I remember the first time I heard water swishing around in my stomach (while running) and thinking that maybe I had a tumor.

I remember thinking how awful it would be to be responsible for a fire that took lives. Or for a car wreck.

I remember when I was very young a photograph in "Life" magazine of a man running down the street naked on fire.

I remember my father trying to get splinters out of my fingers with a needle.

I remember daydreams of living in an old bus, or an old railroad car, and how I would fix it up.

I remember daydreams of having a pet monkey that would wear human clothes and we would go around everywhere together.

I remember daydreams of inheriting lots of money from

some relative I didn't even know I had.

I remember daydreams of being a big success in New York City. (Penthouse and all!)

I remember living on the Lower East Side.

I remember Second Avenue and strawberry shortcake at "Ratner's."

I remember the St. Mark's movie theatre (45¢ until six). The red popcorn machine. And lots of old men.

I remember "the cat lady" who always wore black. And many pairs of nylons. One on top of the other on top of the other. She was called "the cat lady" because every night she went around feeding cats. Her hair was so matted I don't think a comb could possibly have gone through it. All day long she roamed the streets doing what I am not sure. She was never without her shopping cart full of paper bags full of God only knows what. According to her there were other cat ladies who looked after cats in other Lower East Side areas. How organized all these ladies were I don't know.

I remember Ukranian Easter eggs all year round.

I remember thin flat sheets of apricot candy in delicatessen windows.

I remember "Le Metro." (A coffeehouse on Second Avenue that had poetry readings) Paul Blackburn. And Diane Di Prima sitting on top of a piano reading her poems.

I remember how beautiful snow made the Lower East Side look. (So black and white)

I remember Klein's at Christmas time.

I remember "Folk City." "Man Power." And selling books at "The Strand."

I remember going grocery shopping with Pat Padgett (Pat Mitchell then) and slipping a steak into her coat pocket when she wasn't looking.

I remember going to a church on the Bowery where bums go to get work for a day and being sent to Brooklyn to clean up a small Jewish synagogue where the rabbi was so disgusting that after half a day's work I just couldn't stand anymore so I "disappeared." (With no pay)

I remember Leadbelly records smaller than most records.

I remember Delancey Street. The Brooklyn Bridge. Orchard Street. The Staten Island Ferry. And walking around the Wall Street area late at night. (No people)

I remember a very old man who lived next door to me on Avenue B. He is most surely dead by now.

I remember that "no two snowflakes are exactly alike."

I remember felt jackets from Mexico with felt cut-outs of Mexicans taking siestas on the backs. And potted cactus plants on the pockets.

I remember the 4th of July. Sparklers. And stories about how dangerous firecrackers are.

I remember being allowed only sparklers. (And I remember only *wanting* sparklers)

I remember snow, making snow-creams, and never having much luck making snowmen.

I remember making angel impressions in the snow by falling backwards and flapping my arms up and down and my legs back and forth.

I remember hay rides and slumber parties.

I remember little cream jars in restaurants.

I remember "statues." (A game where someone swung you around and then let go and you froze in whatever position you landed)

I remember satin jackets from Japan with embroidered dragons and American flags on the backs.

I remember when pink grapefruit was a big treat.

I remember mackinaws.

I remember roller skate keys.

I remember "Coming Attractions." Company picnics. Two-car garages. And picture windows.

I remember potato sack races.

I remember "Sticks and stones may break my bones but words will never hurt me."

I remember green grass knee stains.

I remember every year in school having to write an essay on thrift for some annual thrift essay contest, and never winning.

I remember not understanding how a baby could come out of such a small hole. (Still don't)

I remember jacks.

I remember "onesies" and "twosies" and "threesies" and "baskets" and "pig pens" and "over the fences" and "around the worlds" and "pats" and "double pats."

I remember "7" and "14" and "13" and "21" and "69".

I remember daydreams of having supernatural powers and amazing people with my accurate predictions.

I remember predicting an airplane crash but nobody would listen. (Daydream)

I remember racoon tails hanging from car antennas.

I remember sassafras tea, turnips, and persimmons.

I remember looking for four-leaf clovers, but not for very long.

I remember Lazy Susans.

I remember continuing my return address on envelopes to include "The Earth" and "The Universe."

I remember Dole pineapple rings on a bed of lettuce with cottage cheese on top and sometimes a cherry on top of that.

I remember "Korea."

I remember giant blackheads on little faces in tiny ads in the back of magazines.

I remember fancy yo-yos studded with rhinestones.

I remember once when it was raining on one side of our fence but not on the other.

I remember rainbows that didn't live up to my expectations.

I remember big puzzles on card tables that never got finished.

I remember Oreo chocolate cookies and a big glass of milk.

I remember vanilla pudding with vanilla wafers in it and sliced bananas on top.

I remember angel food cake and wondering why the hole in the middle *had* to be there.

I remember my mother's sticking toothpicks into cakes to see if they were done or not.

I remember borrowed punch bowls.

I remember fantasies of totally losing my voice and hearing and being able to communicate only by writing notes back and forth. (It was fun!)

I remember trying not to stare at people with hearing aids. (Or trying to look at them casually)

I remember braces (on teeth) and how, at a certain point in high school it was almost a status symbol.

I remember being embarrassed to blow my nose in public.

I remember not going to the bathroom in public places if I didn't know where it was.

I remember, when traveling, laying tissue paper over the toilet seat rim because "You never know."

I remember "number one" and "number two."

I remember examining my cock and balls very carefully once and finding them absolutely disgusting.

I remember fantasies of my cock growing quite large just overnight. (A medical mystery!)

I remember sexual fantasies of having "to perform" by force.

I remember Coke bottle stories.

I remember reading somewhere that the average cock is from six to eight inches when erect, and grabbing for the nearest ruler.

I remember stories about nuns and candles and throwing babies into the basement furnace.

I remember cheating at solitaire.

I remember sometimes *letting* people win games.

I remember crossing your fingers behind your back when you tell a lie.

I remember thinking that comic books that weren't funny shouldn't be called "comic books."

I remember fantasies of making the back seat of a car "livable" with curtains, a fold-away kitchen, etc.

I remember fantasies of growing up and adopting a child.

I remember trying to imagine what I'd look like as an old man.

I remember old women's flesh-colored hose you can't see through.

I remember "no ankles" on some old ladies.

I remember trying to imagine my grandfather naked. (Eck!)

I remember having a crush on a cousin and mother telling me that you can't marry a cousin and, "But *why* can't you marry a cousin?" and, "Because it's against the law," and, "But *why* is it against the law?" etc.

I remember the rumor that if a black and a white person got married and had a baby it might turn out black and white spotted.

I remember a boy who could curl up his lips ("nigger lips") and hold them there.

I remember white marshmallow powder on lips.

I remember a very big boy named Teddy and what hairy legs his mother had. (Long black ones squashed flat under nylons)

I remember Dagwood and Blondie shorts before the feature started.

I remember not allowing myself to start on the candy until the feature started.

I remember big battle scenes and not understanding how they could be done without a lot of people getting hurt.

I remember thinking those sandals and short skirts rather impractical for war.

I remember how very black and white early "art" movies were.

I remember bedroom scenes that focused mostly on the wallpaper.

I remember Gina Lollobrigida's *very* tiny waist in "Trapeze."

I remember bedroom scenes where the camera goes out the window and down to the ocean to the roar of crashing waves.

I remember Jane Russell's hair all pulled over to one side and flat as a rock on top.

I remember that Rock Hudson and Charlie Chaplin and Lyndon Johnson have "giant cocks."

I remember rumors about what Marlon Brando had to do to get his first acting job.

I remember the rumor that Marlon Brando liked Oriental women so much because he had a little cock.

I remember giant discussions with Pat and Ron Padgett, and Ted Berrigan, after seeing "La Dolce Vita" about what all the symbolism meant.

I remember the shadows of feet under the cracks of doors. And closeups of doorknobs turning.

I remember getting irritated when someone would get out of bed and roam around the castle all alone late at night (just asking for trouble) instead of staying in his or her room where it's safe.

I remember hair not being messed up when it should be messed up.

I remember when you do that motorboat-like thing with your lips how your nose starts tickling.

I remember jungle plants that eat people.

I remember candy cigarettes like chalk.

I remember finding things in glove compartments I had looked for there before and not found.

I remember screen doors that slam. And "You're letting in the flies."

I remember bar stools and kitchen nooks and brass ivy planters.

I remember tap dancing recitals.

I remember Popsicle coupons. Ballerina paper dolls. And carnival glass piggy banks with no way to get the money out except by shaking it out upsidedown.

I remember a tin clown bank that stuck his tongue out and a monkey bank that tipped his hat.

I remember veils over hats over faces sprinkled with little fuzzy dots.

I remember parliamentary procedure. Multiple choice questions. And paper curtains.

I remember "Aspergum." And muumuus. And making Easter baskets out of Quaker oatmeal boxes at school.

I remember houseshoes that were just leather soles sewn to the bottoms of a pair of socks.

I remember roly-poly bugs that curl up into a ball when you touch them.

I remember those yellow bushes that are the first things to flower in the spring.

I remember when I was very young telling an adult that I wanted to be a fireman or a cowboy when I grew up but I don't remember really wanting to be either.

I remember Jane and Dick and Sally and Spot and the nice policeman and "Run, run, run."

I remember in many classrooms a painting of George Washington unfinished at the bottom.

I remember okra, hominy grits, liver, and spinach.

I remember that carrots are good for your eyes and that beans make you fart.

I remember that cats have nine lives.

I remember "An apple a day keeps the doctor away."

I remember puffed rice shot from guns.

I remember "Snap, crackle, and pop."

I remember an ashtray that looked like a house and when you put your cigarette down (through the door) the smoke came out of the chimney.

I remember Rudolph the Red-Nosed Reindeer.

I remember a toothpick holder with a bird that picked up the toothpick with his beak for you when you did something (?) to his tail.

I remember "just married" cartoons.

I remember "stranded on an island in the middle of the ocean" cartoons.

I remember high school year books, signing high school year books, and "Roses are red, violets are blue, God made me beautiful, what happened to you?"

I remember in a high school year book a big group picture where one boy in the back row was giving the finger.

I remember the same year in the same year book a picture of a track star running and if you looked real close you could see what looked like the tip of his penis sticking out from under his shorts.

I remember "My Wild Irish Rose."

I remember how "Penny" in the Sunday comics was always talking on the telephone in unusual positions surrounded by mountains of food.

I remember that Penny's father always had a pipe in his mouth.

I remember the tobacco smell of my father's breath.

I remember my father's collection of Zane Grey novels and one "dirty" book called *Let's Make Mary*.

I remember plaster of paris.

I remember plaster of paris figurines you made in red rubber molds and then you painted them.

I remember accent pillows. Bathroom decals. Argyle socks. Window valances. And tapioca pudding.

I remember cold cream. "Tums for the tummy." And "Our Miss Brooks."

I remember book ends. Arm chairs. And end tables.

I remember "Amos and Andy." "Life with Father." And "Francis the Talking Mule."

I remember artist smocks. Liver-shaped palettes. And big black bows.

I remember "Ma and Pa Kettle." "Dishpan hands." Linoleum. Cyclone fences. Shaggy dog stories. Stucco houses. Pen and pencil sets. Tinker Toys. Lincoln Logs. And red blue jeans for girls.

I remember a pair of brown blue jeans I once had.

I remember thinking how embarrassing it would be if your name was Hitler.

I remember a miniature white Bible no bigger than a book of matches.

I remember finding the story of Noah and his ark really just *too* far out.

I remember "God Is Love Is Art Is Life." I think I made that up in high school. Or else Ron Padgett did. At any rate I remember thinking it terribly profound.

I remember queer bars.

I remember leaning up against walls in queer bars.

I remember standing up straight in queer bars.

I remember suddenly being aware of "how" I am holding my cigarette in queer bars.

I remember not liking myself for not picking up boys I probably could pick up because of the possibility of being rejected.

I remember deciding at a certain point that I would cut through all the bullshit and just go up to boys I liked and say "Do you want to go home with me?" and so I tried it. But it didn't work. Except once. And he was drunk. The next morning he left a card behind with a picture of Jesus on it signed "with love, Jesus" on the back. He said he was a friend of Allen Ginsberg.

I remember tight white pants. Certain ways of standing. Blond heads of hair. And spotted bleached blue jeans.

I remember "baskets."

I remember "jewels" neatly placed down the left pant leg or the right.

I remember pretty faces that don't move.

I remember loud sexy music. Too much beer. Quick glances. And not liking myself for playing the game too.

I remember enjoying playing the game too tho.

I remember pretending to be interested in pool.

I remember a boy I tried to pick up once. As an opener I told him he had a nice nose and he said he was thinking about having it "fixed" and I said no he shouldn't. He said he was busy that night but he took my phone number. (Never did call tho) Maybe I put him off by saying that I thought psychology was a bit silly. (He was a psychology major) "Too self-indulgent," I remember saying. (I was drunk) Actually his nose *was* a bit too big.

I remember coming home from queer bars and bawling myself out for not having more confidence in myself.

I remember thinking I could sing (had a good voice) until somehow in school I discovered I didn't.

I remember that Picasso was born in 1881. (Having no memory for facts I once made myself memorize that fact and I've never forgotten it)

I remember "A white sports coat and a pink carnation."

I remember the "dum-da-dum-dum-*dum*" from "Dragnet."

I remember what a hard time I had memorizing Shake-speare and how nervous I got when it was my turn to recite.

I remember trying to memorize Shakespeare so that

words that began with sounds I stuttered on (S, B, etc.) would not begin with a new breath. (Do you know what I mean?)

I remember chartreuse.

I remember a pair of baby blue gabardine pants I especially liked.

I remember running for vice-president and giving a campaign speech wearing my baby blue gabardine pants. I lost. That was junior high school.

I remember in junior high school asking a girl who was much too popular and pretty for me to a dance and she said, "Yes." But the moment we arrived she disappeared into a group of her friends and I didn't see her again all evening. I think her name was Nancy. Yes, it was.

I remember that Nancy was the girl I lost the vice-presidency to.

I remember Judy.

I remember having a big crush on Judy and discovering that she was embarrassed to be seen with me so I stopped asking her out.

I remember Bill Haley and "Rock Around the Clock."

I remember thin gold ankle bracelets.

I remember "white trash."

I remember nylon "runs."

I remember looking at myself in a mirror and becoming a total stranger.

I remember having a crush on a boy in my Spanish class who had a pair of olive green suede shoes with brass buckles just like a pair I had. ("Flagg Brothers") I never said one word to him the entire year.

I remember sweaters thrown over shoulders and sunglasses propped up on heads.

I remember boat neck sweaters.

I remember "Queer as a three dollar bill."

I remember wooden nickels.

I remember stamp hinges.

I remember orange icing on cupcakes at school Halloween parties.

I remember autumn.

I remember walking home from school through the leaves alongside the curb.

I remember jumping into piles of leaves and the dust, or whatever it is, that rises.

I remember raking leaves but I don't remember burning leaves. I don't remember what we "did" with them.

I remember "Indian Summer." And for years not knowing what it meant, except that I figured it had something to do with Indians.

I remember exactly how I visualized the Pilgrims and the Indians having the first Thanksgiving dinner together. (Very jolly!)

I remember Jack Frost. Pumpkin Pie. Gourds. And *very* blue skies.

I remember Halloween.

I remember usually getting dressed up as a hobo or a ghost. One year I was a skeleton.

I remember one house that always gave you a dime and several houses that gave you five cent candy bars.

I remember after Halloween my brother and me spreading all our loot out and doing some trading.

I remember always at the bottom of the bag lots of dirty pieces of candy corn.

I remember the smell (not very good) of burning pumpkin meat inside jack o'lanterns.

I remember orange and black jellybeans at Halloween. And pastel colored ones for Easter.

I remember "hard" Christmas candy. Especially the ones

with flower designs. I remember not liking the ones with jelly in the middle very much.

I remember some beautiful German Christmas tree ornaments in the shape of birds and houses and people.

I remember the dangers of angel hair.

I remember having my Christmas shopping list all made out before December.

I remember the fear of not getting a present for someone who might give me one.

I remember after Christmas shopping coming home and gloating over everything I bought.

I remember Rosemary Clooney and Bing Crosby and "I'm Dreaming of a White Christmas."

I remember how sad and happy at the same time Christmas carols always made me feel: all warm inside.

I remember seeing every year that movie about "Macy's" and "Gimbel's" and the old man who thought he was Santa Claus.

I remember, after Christmas caroling, hot chocolate.

I remember buying a small bottle of Chanel No. 5 for my mother for Christmas one year but when I told my father how much it cost I had to take it back.

I remember not being able to fall asleep Christmas Eve.

I remember more than once leaving the price tag on a present.

I remember very clearly (visually) a bride doll sitting in a red wagon under the Christmas tree when I was very young. (For me)

I remember opening my first packages very fast and my last few very slowly.

I remember after opening packages what an empty day Christmas day is.

I remember feeling sorry for kids at church, or school, who had ugly mothers.

I remember that nobody ever knew what to give Aunt Ruby on special occasions so everyone always gave her stationery or scarves or handkerchiefs or boxes of fancy soap.

I remember thinking I had really hit on something when I got the idea of putting orange juice instead of milk on cereal but then I tried it and it was awful.

I remember loving raw biscuit dough.

I remember rolling balls of mercury around in the palm of my hand, and shining dimes with it.

I remember the controversy over whether to install a Coke machine in the church basement or not.

I remember church camp and "the quiet hour" and weaving plastic braid around strips of metal to make bracelets. And

weaving plastic braid into things to hang around your neck to hang whistles from. And always the possibility of running into a copperhead.

I remember being a Boy Scout and getting badges in art and finger printing and several other easy-to-get badges. First-aid too.

I remember hoola-hoops.

I remember seeing my brother bend way over to pull out the bath tub plug naked and realizing for the first time that shit came out of a hole instead of a long slit.

I remember a pinkish-red rubber douche that appeared in the bathroom every now and then, and not knowing what it was, but somehow knowing enough not to ask.

I remember when I was very young getting what I now assume to have been an enema. I just remember having to turn over and my mother sticking this glass thing with a rubber ball on top (also pinkish-red) up my butt and being scared to death.

I remember getting a thermometer stuck up my butt several times and the fear that it might fall in and get lost, or break off inside me.

I remember a little boy who said it was more fun to pee together than alone, and so we did, and so it was.

I remember once my mother parading a bunch of women through the bathroom as I was taking a shit. Never have I been so embarrassed!

I remember a boy who could pull the undersides of his eye lids down over his eyeballs.

I remember looking cross-eyed and being told not to do that because they might get stuck and I'd be cross-eyed for life.

I remember a story about somebody finding a baby alligator in their toilet bowl.

I remember peeing all over J. J. Mitchell in a dream once.

I remember very long pigtails. And plaid ribbon bows.

I remember finding some strange looking stamps in a box and being told that you got food with them during the war.

I remember a big red satin wide-brimmed hat with red silk poppies all over it Mrs. Hawks wore to church one Easter Sunday. She was married to Mr. Hawks who owned the local ice cream company. She was an ex-Dior model and everyone thought she was very ugly except me. ("Skinny and weird looking") In my head it is still the most beautiful hat I have ever seen.

I remember wax fingernails. Wax moustaches. Wax lips. And wax teeth.

I remember that George Washington's teeth were made of wood.

I remember little wax bottles with very sweet liquid inside.

I remember orange candy shaped like big peanuts with lots of air in it.

I remember pink cotton candy and feeling all "sticky" afterwards.

I remember looking very close at cotton candy and seeing that it was made up of little red "beads."

I remember a coconut kind of candy that looked like thin slices of watermelon.

I remember "nigger babies." Candy corn. And red hots.

I remember finger painting and usually ending up with a sort of purple-brown mess.

I remember jungle gyms and girls who didn't care if you saw their panties or not.

I remember one girl who sometimes didn't wear panties.

I remember "dress up time." (Running around pulling up girl's dresses yelling "dress up time")

I remember that a lot of kissing went on in the drinking fountain area.

I remember fire drills. And air-raid drills.

I remember a chubby boy whose parents were deaf and dumb. He taught me how to say "Joe" with my hands.

I remember daydreams of having a twin.

I remember "See you later alligator!"

I remember suspenders and bow ties and red leather mittens.

I remember, when someone says something that rhymes, "You're a poet, and didn't know it, but your feet show it. They're Longfellows!"

I remember yellow rubber raincoats with matching hoods.

I remember big black galoshes with lots of metal foldover clamps.

I remember a *very* deluxe Crayola set that had gold and silver and copper.

I remember that the red Crayola was always the first to go.

I remember always drawing girls with their hands behind their backs. Or in pockets.

I remember that area of white flesh between the pant cuffs and the socks when old men cross their legs.

I remember a fat man who sold insurance. One hot summer day we went to visit him and he was wearing shorts and when he sat down one of his balls hung out. I remember that it was hard to look at it and hard not to look at it too.

I remember a very early memory of an older girl in a candy store. The man asked her what she wanted and she picked out several things and then he asked her for her money and she said, "Oh, I don't have any money. You just asked me what I *wanted*, and I told you." This impressed me no end.

I remember daydreams of living in a tree house.

I remember daydreams of saving someone from drowning and being a hero.

I remember daydreams of going blind and how sorry everyone would feel for me.

I remember daydreams of being a girl and of the beautiful formals I would have.

I remember daydreams of leaving home and getting a job and an apartment of my own.

I remember daydreams of being discovered by a Hollywood agent who would send me to a special place in California where they "re-do" people. (*Very* expensive) They'd cap my teeth and make my hair look great and make me gain weight and give me muscles and I'd come out looking great. On my way to being a star. (But first I'd go home and shock everybody.)

I remember daydreams of a doctor who (on the sly) was experimenting with a drug that would turn you into a real stud. All very "hush-hush." (As it was illegal) There was a slight chance that something might go wrong and that I'd end up with a *really* giant cock, but I was willing to take that chance.

I remember wondering if I *looked* queer.

I remember making sure that I held my cigarette in not a queer way.

I remember one masculine looking way to hold a cigarette I figured out was to hold it way down between my fingers. Below the knuckles.

I remember not crossing my legs. (Knee over knee) I thought that looked queer.

I remember making sure my little finger didn't stick out.

I remember hating myself after group gatherings for being such a bore.

I remember daydreams of being very charming and witty.

I remember my first pep pill. Ted Berrigan gave it to me. I stayed up all night doing hundreds of drawings. I especially remember one drawing of a cup of coffee.

I remember "Spam."

I remember when I was very young thinking that shaving looked pretty dangerous.

I remember rubber thongs and how they started out being 99¢ a pair and how they ended up being incredibly cheap (like 19¢ a pair) and the sound they made flopping against bare soles.

I remember chicken fried steak.

I remember "Kraft's" sandwich spread.

I remember not trusting pressure cookers.

I remember a blue glass mirror store front in Tulsa with one piece missing.

I remember "Sloppy Joes."

I remember shoulder pads. Cinnamon toothpicks. And "John Doe."

I remember little electric fans that could "cut your fingers right off" if you got too close.

I remember little boxes of cereal that opened up in back so you could eat it right out of the box. I remember that sometimes they leaked.

I remember cedar chests. (And the smell of)

I remember "blond oak."

I remember when the bigger the cuffs on blue jeans were the better.

I remember "5-Day Deodorant Pads."

I remember "The Arthur Murray Party."

I remember pony tail clips.

I remember "Chef Boy-ar-dee Spaghetti."

I remember baby shoes hanging from car rear-view mirrors.

I remember bronzed baby shoes. Shriner hats. And the Campbell Soup kids.

I remember cold cream on my mother's face.

I remember two-piece bathing suits. Alphabet soup. Ozzie and Harriet. And pictures of kidney-shaped swimming pools.

I remember a photograph in "Life" magazine of a woman jumping off a building.

I remember not understanding how the photographer could have just stood there and taken that picture.

I remember not understanding how very ugly or deformed people could stand it.

I remember a girl in junior high school who had a very thin black mustache.

I remember not understanding why women in dresses didn't freeze their legs off in the winter time.

I remember a girl who had dead corsages all around her circular dressing table mirror.

I remember a brief period in high school when it was popular to spray a silver streak in your hair.

I remember that I was a year ahead of everyone in high school by wearing sneakers but I missed the point a bit because I always kept mine spotlessly clean.

I remember seeing a 3-D movie once and wearing red and green cellophane glasses. And 3-D comic books too.

I remember a series of Cadillac ads with beautiful diamond and ruby and emerald necklaces, according to the color of the car in the ad.

I remember the little monkey so small he would fit in the palm of your hand that you had to sell so much of something for in order to get free. (Seeds or magazines or something like that)

I remember in many comic books a full page ad packed solid with rings. I remember especially one skull ring I always wanted.

I remember a red liquid medicine for cuts in a little brown

bottle that "won't sting" but it always did.

I remember stories about babies being born in taxi cabs.

I remember when Arthur Godfrey caused a big scandal by driving his airplane drunk and having a crash and killing someone, or something like that.

I remember the little appliqued diver on all Jantzen swim suits.

I remember filling the ice trays too full and trying to get them back to the refrigerator without spilling any.

I remember not finding "The Little King" very funny.

I remember a piece of old wood with termites running around all over it the termite men found under our front porch.

I remember when one year in Tulsa by some freak of nature we were invaded by millions of grasshoppers for about three or four days. I remember, downtown, whole sidewalk areas of solid grasshoppers.

I remember a shoe store with a big brown x-ray machine that showed up the bones in your feet bright green.

I remember the "Goodyear" tire foot with wings. And the flying red horse.

I remember that watermelon is 99% water.

I remember posture pictures being taken at school and being told that I had *really* bad posture. And that was that.

I remember fire insurance ads of homeless families all wrapped up in blankets.

I remember little black and white Scottie dogs (plastic) each with a magnet on the bottom. I can't remember exactly what they "did" tho.

I remember prophylactic machines in gas station bathrooms.

I remember that a used prophylactic was found one morning by the principal laying in the outstretched hand of "The Great Spirit": a big bronze sculpture of an Indian on a horse looking up at the sky. That was in high school. Or maybe it was a used kotex.

I remember talk about one drug store that was easy to get them at.

I remember a short dumpy girl with long hair and pierced ears and giant tits that was supposed to be an easy lay.

I remember every other Saturday having to get a haircut. And how the barber was always clicking his scissors even when he wasn't cutting anything.

I remember a long brown leather strap. Beat-up magazines. And kids who cried. (And then got suckers)

I remember the bright red hair tonic that looked more like something to drink, and a white strip of tissue paper being wrapped tightly around my neck.

I remember watching my hair fall and accumulate.

I remember being afraid that the barber might slip and cut my ear.

I remember that once he did.

I remember at the end of a haircut getting my neck dusted off with a soft brush full of nice smelling powder. And getting swirled around to look in the mirror and how big, afterwards, my ears were.

I remember the *very* ornate chrome foot rest. And the old Negro shoeshine man.

I remember having an itchy back all the way home.

I remember a tower on top of a building in Tulsa that changed colors every few minutes. But only green and yellow and white.

I remember miniature hats in miniature hat boxes in a men's hat store window. You got one free when you bought someone a gift certificate for a hat.

I remember balloon sleeves. And no sleeves.

I remember "bouffants" and "beehives." (Hairdos)

I remember when "beehives" really got out of hand.

I remember school desk carvings and running my ball point pen back and forth in them.

I remember noisy candy wrappers when you don't want to make any noise.

I remember when those short sleeved knitted shirts with long tails (to wear "out") with little embroidered alligators on the pockets were popular.

I remember plain camel hair coats that rich girls in high school wore.

I remember "socialite corner" (2nd floor) where only kids who belonged to social clubs met and chatted before school and inbetween classes.

I remember that to be in a social club you either had to live on the South side of town (I lived on the North) or else you had to be good looking (I wasn't) and usually both.

I remember that popular boys always had their blue jeans worn down just the right amount.

I remember madras plaid shirts and sports coats and how they had to be washed a few times before they had the right look.

I remember "French kissing" and figuring out that it must have something to do with the tongue since there isn't anything else in the mouth except teeth.

I remember that shaking or holding hands with a girl while you scratched her palm with your middle finger was somehow "dirty." (Often done as a joke and the girl would turn red and scream)

I remember in Boston a Puerto Rican boy who worked behind a glass counter in a cafeteria and his arms up to his rolled up sleeves: thick and gold and hairless.

I remember early sexual experiences and rubbery knees. I'm sure sex is much better now but I *do* miss rubbery knees.

I remember the first time I got jerked off (never did discover it for myself) I didn't know what she was trying to do and so I just laid there like a zombie not helping one bit.

I remember her wanting me to put my finger in her cunt and so I did but I had no idea (or no inspiration) as to what to "do" with it once it was there except to move it around a bit.

I remember feeling very outside the experience (watching myself) and feeling very silly with my finger in this wet hole. I think she finally gave up and made herself come because I remember a lot of hard kissing while I could feel her squirming around a lot down there.

I remember, on the verge of coming, thinking that *that* meant I had to go pee, so I excused myself to go to the bathroom and that spoiled everything.

I remember being very proud of myself the next morning, nevertheless.

I remember Nehru jackets.

I remember when turtle necks were big, talk about what restaurants would let you in and what ones wouldn't.

I remember the first time I ate beefsteak tartar eating lots of crackers and butter with it.

I remember linen dresses from behind after having sat through a sermon. Or a bridge party.

I remember "The Millionaire" on T.V. and how you never got to see his face.

I remember "Two hairs past a freckle" when someone asks you what time it is and you don't have a watch.

I remember when I was very young a hand wringer washing machine in our basement and visions of what it could do to your hand if it got caught in it.

I remember pink underwear sometimes when something red faded in the wash.

I remember sometimes blue underwear.

I remember lint all over blue jeans when you forgot and left a Kleenex in your pocket.

I remember "panty raids."

I remember "Which twin has the Toni!"

I remember "Does she or doesn't she?"

I remember "There's No Business Like Show Business" (the song) and how it always got to me.

I remember folding paper into cootie catchers. And airplanes that just went down.

I remember picture card machines at the fair of movie starts and pin-up girls and cowboys.

I remember thinking that if you didn't return stamp ap-

provals you'd *really* get in trouble.

I remember at junior high school dances mostly just girls dancing with girls.

I remember "Silly Putty" in a plastic egg.

I remember silent moments in church when my stomach would decide to growl.

I remember daydreams of living in the past and having the advantage (and sometimes the disadvantage) of knowing what was going to happen before it happened.

I remember always breaking my glasses and being told that *next* time I'd have to buy new ones myself out of my allowance (25¢ a week) but I never did.

I remember "Monopoly" and "Clue."

I remember the little silver candlestick (Clue) and not knowing what a conservatory was.

I remember getting all dressed up to go buy clothes.

I remember when twins dressed alike.

I remember mother and daughter dresses.

I remember father and son dinners.

I remember the Lone Ranger and Tonto.

I remember:
 "High-ho Silver in the air
 Tonto lost his underwear
 Tonto, Tonto he no care
 Lone Ranger buy him 'nother pair."

I remember pulling out the long stringy things from the center of honeysuckle blossoms and sucking up the drop of honey that comes out with them.

I remember a bust of Benjamin Franklin on a cover of "The Saturday Evening Post" once every year.

I remember "a ham" every year for Christmas from the company my father worked for.

I remember bright colored bubble bath balls. And bath tub "rings."

I remember clear plastic high heels with no straps in back.

I remember clear plastic purses that looked like lunch boxes with a scarf hanging out of them.

I remember a pink hairnet my mother had with larger than usual openings.

I remember neckties that were already tied with elastic to go around your neck.

I remember "Mother's Day" and wearing a red rose to church in my lapel. (You wore a white rose if your mother

was dead. And a yellow rose if your mother was a step-mother)

I remember "bunny hops." "Picture hats." And toilet paper and chicken wire floats.

I remember my mother telling stories about funny things I'd do and how the stories got funnier each time they were told.

I remember daydreams of finding out I have only a certain amount of time to live ("cancer" usually) and trying to figure out how to best spend what time I had left.

I remember driving through the Ozarks and chenille bedspreads with peacocks on them hanging outside on clotheslines for sale.

I remember in souvenir shops miniature wishing wells of highly shellacked orangey colored wood. And miniature outhouses too.

I remember wondering why out-house doors have a sliver of a moon cut out of them.

I remember, sitting out in the out-house, wondering why it never got filled up.

I remember, sitting out in the out-house, visions of what it would be like to fall in.

I remember solid red when you close your eyes to the sun.

I remember big "Boy's Town" stamps.

I remember alligator purses.

I remember, when babies fall down, "oopsy-daisy."

I remember, with a limp wrist, shaking your hand back and forth real fast until it feels like jelly.

I remember trying to get the last of cat food from a can.

I remember when a piece of hair stands up straight after a night of sleeping on it wrong.

I remember before green dishwashing liquid.

I remember a free shoehorn with new shoes.

I remember never using shoehorns.

I remember not finding pumpkin pie very visually appealing.

I remember the pale green tint of Coca-Cola bottles.

I remember not really trusting mince meat pie. (What was "in" it) And dressing too.

I remember the way cranberry sauce slides out of the can, and then plops.

I remember cold turkey sandwiches.

I remember trying to pull a bandaid off with one quick yank.

I remember fancy little bathroom towels not for using.

I remember two years of cheating in Spanish class by lightly penciling in the translations of words.

I remember No. 2 yellow pencils with pink erasers.

I remember some teachers that would let you get up to use the pencil sharpener without having to ask.

I remember the rotating system of seating where, every Monday, you moved up a seat.

I remember in wood-working class making a magazine rack.

I remember "droodles." (Visual jokes composed of a few simple lines) The idea being "What is it?" (A tomato sandwich) (Two elephants not on speaking terms) (Etc.)

I remember learning to dive in swimming class, because I *had* to, but I never dove again.

I remember wondering why your head didn't get full of water through your ears and nose.

I remember stories about parents throwing their babies into the water, and just by instinct they learn to swim.

I remember, finally, learning to float. But I never did *really* believe it was the water that was holding me up. I suppose I somehow thought I was doing it through sheer willpower. (Mind over matter, so to speak) At any rate, I never did give any credit to the water.

I remember peeing underwater in my bathing suit once, and how sexy and warm it felt.

I remember stories about how people did it all the time in public swimming pools. (Which I rarely got to go to because of the possibility of catching polio)

I remember the indescribable smell of a certain dime store downtown, with wooden floors. Great banana cake. And my favorite 25¢ photo machine. My favorite because it once got stuck, and continued making pictures of me for what seemed like hours, until a nearby clerk became suspicious and called the manager over to turn the thing off.

I remember little white fingernail spots.

I remember biting on a little piece of flesh inside my mouth until a very sweet sort of pain came.

I remember Noble and Fern (my mother's brother and his wife) and that she never stopped talking ("a blue streak") and that he never said a word. They had two kids, Dale and Gale. Dale was so plain that, actually, I'm not sure if I remember him or not. But I *do* remember Gale. She was very cute, and bubbly, and totally obnoxious. She took piano lessons *and* singing lessons *and* dancing lessons. They lived in California and traveled around a lot, by car, never stopping in restaurants for food. (They traveled *with* food) They'd come visit us about once every three years with a slide projector and recent (3 years worth of "recent") travel slides. And, in a plastic coat hanger bag, a fancy costume for Gale, who did her "number" almost immediately upon arrival. These visits were nothing to look forward to. But, after three or four days they would leave, with lots of sandwiches, and, "You've really *got*

to come and see us in California!"

I remember visiting once a very distant relative who had a son about my age (8 or so) who had been saving pennies all his life. It was one of those living rooms packed solid with large furniture, and to top it off, every inch of available space was full of giant jars full of pennies. Even on the floor, and even in the hallway, lined up against the walls, were giant jars full of pennies. Really, it was a very impressive sight. Quite a "haul" for a boy my own age. I was green. (I hope I'm not exaggerating but, no, I don't think I am.) Really, it was almost holy: like a shrine. I remember his mother smugly saying that he (8 years old!) was saving it to send himself through college.

I remember trying to save money, for a day or two, and quickly losing interest.

I remember very tempting little ads in the backs of magazines for like say 25 dresses ("used" in *very* small print) for only one dollar!

I remember in speech class each fall having to give a speech about "what I did this summer." I remember usually saying that I swam a lot (a lie) and painted a lot (true) and did a lot of reading (not true) and that the summer went very fast (true). They always have, and they still do. Or so it seems once summer is over.

I remember, on cold mornings, counting to ten before making myself jump out of bed.

I remember daydreams of going with an absolutely knock-out girl, and impressing all my friends no end.

I remember wondering how one would go about putting on a rubber gracefully, in the given situation.

I remember (in a general sort of way) many nights in bed just holding myself through soft flannel pajamas.

I remember cold sheets in the winter time.

I remember when everything is covered with snow, out the window, first thing in the morning: a really clear surprise. It only snowed about twice a year in Tulsa and, as I remember now, usually during the night. So, I remember "snow" more than I remember "snowing."

I remember not understanding the necessity of shoveling the sidewalks. It always melted in a day or two anyway. And besides—"It's only snow."

I remember thinking Brownie uniforms not very pretty: so brown and plain.

I remember fantasies of everyone in my family dying in a car wreck, except me, and getting lots of sympathy and attention, and admiration for being so brave about it all.

I remember fantasies of writing a very moving letter to the President of the United States about patriotism, and the President, very moved by my moving letter, distributes copies of it to the media (T.V., magazines, newspapers, etc.) and I become one very famous child.

I remember daydreams of going through old trunks in attics, and finding fantastic things.

I remember daydreams of being a very smart dresser.

I remember white socks with a thin red and blue stripe at the top.

I remember (visually) socks on the floor, tossed after a day of wear. They always look so comfortable there.

I remember early fragments of daydreams of being a girl. Mostly I remember fabric. Satins and taffetas against flesh. I in particular remember yards and yards of royal blue taffeta (a *very* full evening dress, no doubt) all bunched up and rubbing between my thighs, by big hands. This period of fantasizing about being a girl wasn't at all sexual in terms of "sex." The kick I got didn't come from being with a man, it came from feeling like a woman. (Girl) These fantasies, all so much one to me now, were all very crunched up and fetus-like. "Close." An orgy of fabric and flesh and friction (close-ups of details) But nothing much "happened."

I remember fantasies of being in jail, and very monk-like in my cell, hand-writing out a giant great novel.

I remember (on the other hand) fantasies of being in jail, and of good raw sex. All very "black and white" some how. Black bars, white tiles. White flesh, black hairs. The rubbery warm whites of cum, and the shiny cold blacks of leather and slate.

I remember (here's a real let-down for you) fantasies of opening up an antique store, with only *very* selective objects, displayed sparsely in an "art gallery" sort of way.

I remember fantasies of opening up an art gallery on the

96

Lower East Side in a store front (I'd live in back) with one exposed wall (brick) and everything else white. Lots of potted plants. And paintings by, you guessed it, me.

I remember building unusual houses in my head. One, very modern and "organic," was inside a cave. Another was mostly glass. And they all had giant bathrooms with giant sunken tubs.

I remember big square glass bricks with a "wavy" surface.

I remember reading the big sex scene on the beach in *Peyton Place*.

I remember sex outdoors playing a big part in my fantasies for a while after that. Usually on the beach. Except that with one art teacher I had it always in the woods.

I remember a lot of fuss about *The Catcher In The Rye*.

I remember sexy photos of Julie London on record covers.

I remember the Liz-Eddie-Debbie scandal.

I remember "Uranium."

I remember *Kon-Tiki*.

I remember talk about flying saucers, before I knew what they were, but never asking.

I remember two-toned cars. Babysitting for 50¢ an hour. And "I Like Ike."

I remember Agnes Gooch.

I remember on newsstands, "Jet" magazine. But never getting up the courage to thumb through a copy.

I remember Dinah Shore's energetic rendition of "See The U.S.A. In Your Chevrolet." And then a big "smack!" And then lots of teeth. And then lots of eye sparkle.

I remember Jimmy Durante disappearing among spotlighted circles into giant black space.

I remember the small diamond heart necklace that Arlene Francis always wore on "What's My Line?"

I remember the "swoosh" of Loretta Young's skirt as she entered the room each week.

I remember sending some fashion design drawings to "Frederick's of Hollywood" in hopes of being discovered as a child genius fashion designer, but—not a word.

I remember the mostly unique to childhood problem of losing things through a hole in your pocket.

I remember, out walking in the rain, people scurrying by with their faces all crunched up.

I remember blue jeans blotched with bleach.

I remember the elephant stampede in "Elephant Walk."

I remember Elizabeth Taylor in *tons* of white chiffon in —also in "Elephant Walk," I think it was.

I remember that Rock Hudson "is still waiting for the right girl to come along."

I remember, in art movies, two nuns walking by.

I remember pretty women all dressed up in black on witness stands (white hankie in hand) with their legs crossed.

I remember that Lana Turner wore *brown* (ugh) to one of her weddings.

I remember in very scary movies, and in very sad movies, having to keep reminding myself that "it's only a movie."

I remember mean prison wardens.

I remember once hearing about something called "Smell-A-Rama": a movie with associated smells piped into the theater.

I remember the "casting couch."

I remember Marilyn Monroe in fuchsia satin, as reflected in many mirrors.

I remember the rumor that the reason Marilyn Monroe and Joe DiMaggio split up was because Marilyn couldn't get turned on without another girl in bed with them, and Joe got fed up with this.

I remember the Marilyn Monroe-John Kennedy affair rumor.

I remember the Gomer Pyle-Rock Hudson affair rumor.

I remember a very tall girl who always had to show her I.D. card to get in for the "under 12" rate.

I remember blonde furniture.

I remember *21* inch television screens!

I remember George and Gracie, and Harry Vonzell.

I remember (z - z - z) "The Kingston Trio."

I remember when "atheist" was a scary word.

I remember little suits, on little boys, with no lapels.

I remember dining room table leaves.

I remember a brief period of "bad breath" concern: the product of a health class at school.

I remember that "most bad breath is caused by germs."

I remember that germs are *everywhere!*

I remember trying to visualize germs (physically) as they crawl around all over everything.

I remember that my vision of germs pretty much resembled normal insects, only much smaller, of course.

I remember sneezing into my hand, out in public, and then the problem of what to "do" with it.

I remember a piece of soft pink cloth with zig-zag edges, to clean new glasses with.

I remember walking down the street, trying not to step on cracks.

I remember "If you step on a crack, you break your Mother's back."

I remember a somehow slightly strange Christian Science Reading Room.

I remember once, when I was very young, seeing my great-grandmother just before she died. (But my abstract memory of this only allows me to say "prune")

I remember hide-and-seek, and peeking while counting to a hundred.

I remember finding the thought of being an albino somehow more mysterious than just "no color pigment."

I remember gardenia petal brown spots.

I remember corsages with pipe cleaners bent into hearts. With puffs of nets. And long pins with a pearl on the end to pin them on with.

I remember (out-loud) the problems of "pin" and "pen."

I remember that pinning a corsage onto a girl was always made into a joke. (Snicker-snicker)

I remember when father seemed too formal, and daddy was out of the question, and dad seemed too fake-casual. But, seeming the lesser of three evils, I chose fake-casual.

I remember closely examining the opening in the head of my cock once, and how it reminded me of a goldfish's mouth.

I remember goldfish tanks in dime stores. And nylon nets to catch them with.

I remember ceramic castles. Mermaids. Japanese bridges. And round glass bowls of varying sizes.

I remember big black goldfish, and little white paper cartons to carry them home in.

I remember the rumor that Mae West keeps her youthful appearance by washing her face in male cum.

I remember wondering if female cum is called "cum" too.

I remember wondering about the shit (?) ((ugh)) in fucking up the butt.

I remember ping-pong ball dents.

I remember rayon slip-over shirts with knitted bands at the waist.

I remember bathroom doors that don't lock, and trying to pee fast.

I remember, when you've done a real stinker, hoping there won't be someone waiting to rush in right after you.

I remember the disappointments of picking up a developed roll of film at the drugstore.

I remember jumping beans, and how disappointing they were. (Lazy) A few flip-flops, and that was that.

I remember egg salad sandwiches "on white" and large cherry Cokes, at drugstore counters.

I remember drugstore counter stools with no backs, and swirling around and around on them.

I remember when the floor seemed a long way down.

I remember when going to an analyst meant (to me) that you were *real sick*.

I remember magazine pictures of very handsome male models with perfect faces and, with an almost physical pang, wondering what it would be like to look like that. (Heaven!)

I remember those sexy little ads in the back of "Esquire" magazine of skimpy bathing suits and underwear with enormous baskets.

I remember, with a new Polaroid and self-timer, having an outlandishly narcissistic photo fling with myself which (I'm proud to say) soon got pretty boring.

I remember "one iota" and "to coin a phrase."

I remember two dollar bills. And silver dollars.

I remember cartoons about retrieving lost money from

street gratings with chewing gum tied to the end of a piece of string.

I remember Double Bubble gum comics, and licking off the sweet "powder."

I remember a "Clove" chewing gum period. And a "Juicy-fruit" chewing gum period. And then (high school) a period when "Dentyne" somehow seemed a sophisticated choice.

I remember that "Dentyne" is the chewing gum most recommended by dentists.

I remember an algebra teacher who very generously passed me. His name was Mr. Byrd. I think he truly understood that algebra, for me, was totally out of the question, so he pretty much ignored me. (In a nice way) He died the next year of cancer.

I remember globes. Roll down maps. And rubber tipped wooden stick pointers.

I remember pale green walls half way up. And lots of brownish framed prints.

I remember, after school, a period of three or four minutes of lots of locker doors being slammed. And long corridor echoes.

I remember arms hugging zipper notebooks piled with books that, when too loaded down, required some twisted body movements to avoid droppage.

I remember that entering the classroom just as the bell rings is *not* the same as being in your seat when the bell rings.

104

I remember big yellow mums, arranged with autumn leaves, in flower shop windows.

I remember big yellow mum corsages, on brown beaver fur coats, at football games, in magazine pictures.

I remember Necco Wafers the pastel colors of chalk.

I remember the legs of a certain teacher when, every now and then, she revealed nylons rolled down to just below her knees.

I remember a young blonde bland psychology teacher with a face impossible to recall. (Big black glasses) I remember trying to find him sexy, but it was hard.

I remember senior class rings on chains around necks.

I remember little pieces of colored ribbons pinned to blouses and sweaters that meant you were pledging to a social club.

I remember the "fuck you" finger.

I remember that "bastard" lost of lot of weight with me when I found out what it meant. I had expected something *much* worse.

I remember fancy eyeglasses studded with rhinestones.

I remember (on popular boys) plain loafers: the kind of "plain" you had to pay through the nose for.

I remember Linda Berg. She confided in me once, tho she wouldn't "go very far," she really dug having her breasts

played with (which, to me, was going pretty far) and did I think it was wrong? (Help!)

I remember a "white trash" boy with an enormously tall crew cut long after crew cuts were in.

I remember pulling the elastic band of my underwear down behind my balls, which gives your whole sex an "up-lift," which makes you look like you've got more down there than you really do.

I remember the fear of—what if all of a sudden out in the middle of public somewhere you get a hard-on?

I remember sex on too much grass and the total separation of my head from what's going on down there.

I remember when everything is going along just swell ("pant-pant") and then all of a sudden neither one of you knows for sure what to "do" next. (Mutual hesitation) That if not acted upon quickly can be a real, pardon the pun, "downer."

I remember, after a lot of necking, how untheatrical the act of getting undressed can sometimes be.

I remember, in the heart of passion once, trying to get a guy's turtle neck sweater off. But it turned out not to be a turtle neck sweater.

I remember a sex fantasy sequence in my head of being forced to "perform" on the floor, under the stairs, of an apartment building I either lived in, or was visiting, I can't remem-

ber which. Needless to say, the mad sex fiend criminal rapist was pretty cute to boot.

I remember, with the one you love, familiar gestures that can drive you up the wall.

I remember a small top drawer full of nylons, and my mother, in a rush, trying to find two that matched.

I remember finding things in that drawer I wasn't supposed to see, smothered in nylons.

I remember the olive green velvet lining of my mother's olive green "leather" jewelry box, with fold-out trays. When alone in the house, I loved going through it, examining each piece carefully, trying to pick out my favorites. And sometimes, trying on something, but mostly, I just liked to look.

I remember learning very early in life the art of putting back everything exactly the way it was.

I remember affectionate squeezes in public from my father. Usually of a joke-strangle sort. And not knowing how to respond. So I'd turn red, with a big grin on my face, and look down until it was all over with.

I remember how difficult it is to let a "public" grin fall gracefully.

I remember catching myself with an expression on my face that doesn't relate to what's going on anymore.

I remember practicing flexing my jaw muscles, because

I thought it looked sexy.

I remember, when my eyebrows began to spread over my nose bridge, thinking it might make me look a bit more like Montgomery Clift. (A bit *more?*) Yes—I just remembered—I did have a period of secretly thinking I slightly resembled Montgomery Clift.

I remember sitting in the back seat of a car once with a girl named Marilyn, and trying to get my arm behind her without its becoming too obvious a gesture. But it took me so long to be subtle, it became a *very* obvious gesture.

I remember, then, some kissing. And finally getting up the courage to stick my tongue in her mouth, but (what next?) ((Help!)) and so it was just a lot of in and out, and in and out, which started feeling sort of creepy after a while, and I knew I was a flop.

I remember a girl in Dayton, Ohio who "taught" me what to do with your tongue, which, it turns out, is definitely what *not* to do with your tongue. You could really hurt somebody that way. (Strangulation)

I remember feeling sorry for black people, not because I thought they were persecuted, but because I thought they were ugly.

I remember once when I was very young my mother putting metal clamps in her hair to make waves, and I said I wanted some too, so she put some in my hair too. And then, forgetting I had them on, I went outside to play. I don't remember exactly what happened, but I do remember rushing back into the house, humiliated.

I remember my mother picking up tiny specks of lint off things.

I remember, at the end of the sofa, a group of four little pillows that had only one casual arrangement.

I remember that no one sat on the sofa (light beige) unless we had company.

I remember (very vaguely) hearing my mother tell a story about an old lady across the street who died, and the people who moved in after her complaining because they could never quite get rid of "the smell."

I remember horrible visions of that island where lepers were sent.

I remember "the green stuff" inside my first lobster.

I remember (ugh) white nurse shoes.

I remember trying to visualize "the travels" of shit, after you flush the toilet.

I remember, when someone is standing next to you in a public latrine, how long it can seem before you get "started."

I remember Halloween and the annual problem of whether to wear a mask or to see. (Glasses)

I remember glasses on top of satin eye masks.

I remember next door neighbors who don't keep up their lawns.

I remember, the day after Halloween, talk about car door windows getting soaped, and of lawn furniture appearing on unfamiliar porches.

I remember a girl who could bend her thumb all the way back. And a boy who could wiggle one ear at a time.

I remember a lady almost talking my mother into a set of encyclopedias.

I remember starting a set of supermarket encyclopedias, but three was as far as we got.

I remember fantasies of someday reading a complete set of encyclopedias and knowing *everything*.

I remember *enormous* dictionaries.

I remember beautifully colored pastel floor plans of houses, on detective paperback backs.

I remember (from lake life) mosquitos.

I remember mosquito spray. Mosquito bites. And mosquito bite medicine.

I remember the little "thuds" of bugs bumping up against the screens at night.

I remember, at night, heading out into the black to pee, and imagining all the things I might be just about to step on, or "in."

I remember cold mud between your toes, under warm brown water.

I remember trying to put on a not quite dry bathing suit. (ugh)

I remember, inside swimming trunks, white draw strings.

I remember, in a very general way, lots of dark green and brown. And, perhaps, a red canoe.

I remember, one summer way back, a new pair of red sandals. And I hated sandals.

I remember red fingers from eating pistachio nuts.

I remember black tongues from eating licorice.

I remember little packages of colored sugar-like stuff, and just about every different color of tongues.

I remember Katy Keene. And a pair of candy cane eyeglasses her little sister "Sis" had.

I remember Randy, Katy's rich blond beau with cars. And K.O., Katy's poor boxer beau with curly hair and no cars.

I remember secretly feeling that she would someday end up with K.O.

I remember costume dolls with their skirts up in back in square boxes with cellophane "window" fronts.

I remember what I remember most about restaurants when I was *very* young: frenchfries, straws, and toothpicks.

I remember looking out of the windows, riding buses uptown, sudden fantasy flashes of everybody out there on the streets being naked.

I remember sudden fantasy flashes of how many people all over the world are fucking "at this very moment."

I remember "rave review" fantasies. And sell-out shows.

I remember poetry reading fantasies of having everyone in tears. (Good tears)

I remember fantasies of all of a sudden out of the blue announcing "An evening with Joe Brainard" at Carnegie Hall and surprising everybody that I can sing and dance too, but only for one performance. (Tho I'm a smash hit and people want more) But I say "no": I give up stardom for art. And this one performance becomes a legend. And people who missed it could shoot themselves. But I stick to my guns.

I remember (ugh) hound drops.

I remember with fried shrimps in restaurants, not enough tartar sauce.

I remember "French Post Cards."

I remember little round paper clips to attach the price of greeting cards to the card with.

112

I remember greeting cards with, somewhere on them, a real feather.

I remember picnics.

I remember black marshmallows, and inside, a flood of warm white.

I remember that mustard and bottle openers were the traditional things to forget. But I don't remember either ever being forgotten.

I remember laying something across the napkins so they won't blow away.

I remember red plastic forks and green plastic forks.

I remember wooden forks hard to handle a big potato salad lump with.

I remember digging around in ice cold water for an orange soda pop.

I remember Belmondo's bare ass (a movie "first") in a terrible "art" movie called, I think, "Leda."

I remember a lot of movie star nose job rumors.

I remember the cherries on Marilyn Monroe's dress playing paddle-ball in "The Misfits."

I remember in a musical movie about a fashion designer,

a black velvet bat winged suit with a rhinestone cobweb on the back.

I remember slightly "sissy" pants on Italian boys in art movies.

I remember Maria Schell's very wet eyes in "The Brothers Karamazov."

I remember a lot of very rowdy goings on in "Seven Brides For Seven Brothers."

I remember Jane Russell and a lot of muscle men doing a big number around the swimming pool of a luxury liner.

I remember Esther Williams' very large face.

I remember being shown to my seat with a flashlight.

I remember dancing boxes of popcorn and hot dogs singing, "Let's all go out to the lobby, and get ourselves a treat!"

I remember a fashion newsreel about live bug jewelry on a chain that crawled all over you.

I remember finding myself in situations I all of a sudden feel (remember) I've been in before: a "repeat" life flash.

I remember those times of not knowing if you feel really happy or really sad. (Wet eyes and a high heart)

I remember, in crowds—total isolation!

I remember, at parties—naked!

114

I remember body realizations about how fragile we (life) really are (is).

I remember trying to figure things out—(life)—trying to get it all down to something basic—and ending up with nothing. Except a dizzy head.

I remember having a long serious discussion with Ted Berrigan once about if a homosexual painter could paint the female nude as well as a "straight" painter could.

I remember "Now I lay me down to sleep (Etc.)"

I remember, just out of bed in the morning, red wrinkle designs on your skin.

I remember my mother cornering me into corners to squeeze out blackheads. (Hurt like hell)

I remember (hurt like hell) Saturday night hair washings of fingernails to scalp.

I remember predicting that probably someday in the future people would dye their hair all different colors from day to day to match whatever they happened to be wearing that day.

I remember a teacher who used to use the word "queer" a lot (meaning "unusual") and a lot of snickering.

I remember when the word "fairy" began to evoke snickering not knowing why. Then later, I do remember knowing why. What I don't remember is *how* I learned what it meant. Just a gradual process of putting two and two together, I

guess. Plus a bit of speculation.

I remember white rubber sink plugs on chains.

I remember not to stand up in the bathtub because I might slip and fall and bash my head open.

I remember "This is the last time I'm going to tell you."

I remember (in the "But why?" department) "Because I say so, that's why!"

I remember birthday parties.

I remember pink and brown and white ice cream in layers.

I remember little silk American flags. And little bamboo and paper Japanese umbrellas that, if you tried to open them all the way up, broke.

I remember at least once only pretending to make a wish before blowing the candles out.

I remember how hard it was to get a round of "Happy Birthday" going.

I remember never going to a birthday party where we played Pin The Tail On The Donkey.

I remember canned creamed corn.

I remember Cream of Wheat lumps.

I remember roast beef and carrots and potatoes and gravy and, underneath it all, a piece of soggy white bread: the best part.

I remember, when your beet juice runs into your mashed potatoes—red mashed potatoes!

I remember looking forward to a certain thing or event that is going to happen, and trying to visualize its actually happening and not understanding "time" one bit. (Frustrating) Frustrating because, at times, one can almost grab it. But then you realize it's too slippery, and just too complicated, and so you lose your footing, totally back to nowhere. (Frustrating) Still believing that a certain sort of understanding is somehow possible, if approached delicately enough, from just the right angle.

I remember floating transparent spots before my eyes, every now and then, for a moment (microscopic) like when you stand up real fast.

I remember many claustrophobic dreams of being in tight and endless places that get even more tight and more endless, and not being able to get out.

I remember thinking about breathing, and then your head takes over the effort of breathing, and you see that it's "hard work," and it's all very spooky somehow.

I remember teenagers riding around in convertibles with their radios on loud.

I remember (after school) soda fountain shops with booths, and a juke box, but only in the movies.

I remember juke boxes you could see pick up the records.

I remember blowing straws.

I remember "parking."

I remember "necking."

I remember "petting."

I remember "stripped" cars. (No chrome)

I remember Buicks with holes in them. (Three or four along each side, I think it was)

I remember big sponge dice dangling up front.

I remember noisy exhaust pipes.

I remember souvenir state decals on car rear windows. I remember that some cars had a lot.

I remember St. Christopher medals, on chains, around necks, that had nothing to do with being Catholic.

I remember old ladies' houses with a lot of things to break in them.

I remember crocheted doilies on the backs and arms of big stuffed chairs.

I remember maroon and navy blue felt houseshoes, with fuzzy balls on top.

I remember (z - z - z) plastic place mats the texture of woven straw.

I remember boat steering wheel wall lamps.

I remember "Man Tan," and orange stains on white shirts.

I remember trying to get a tan out in the back yard and, thinking I'd been out for an hour or so, going inside to discover that I'd only been out for 15 or 20 minutes.

I remember, after being outside in the sun for awhile, going inside, and the few moments or so of seeing almost negative.

I remember a tall girl with blonde hair who every year got a *really* dark tan. She wore white a lot (to set it off) and light pink "wet" lipstick. Her mother was very tall too. Her father was crippled from polio. They had money.

I remember the smell of Jergen's hand lotion on hands. And its pearly white texture as it oozes from the bottle.

I remember large bars of Ivory soap that broke easily into two. (Actually, now that I think about it, *not* so easily)

I remember the Dutch Cleanser girl with no face.

I remember wondering about the comfort and practicality of wooden shoes.

I remember filling out a form once and not knowing what to put down for "race."

I remember speculating that probably someday all races would get mixed up into one race.

I remember speculating that probably someday science would come up with some sort of miracle cream that could bleach skin, and Negroes could become white.

I remember (*too* recently) writing something I especially liked in a letter and "using" it again in another letter, and feeling a bit cheap about it.

I remember (to be more accurate) feeling cheap about it because I *didn't* feel cheap about it.

I remember "a pot of gold at the end of the rainbow."

I remember no way to scratch your ear in the dentist chair when your ear itches.

I remember "Red Roses For A Blue Lady." (A *blue* lady?)

I remember tie clips that were hard to keep straight.

I remember, in signing off a letter, "Yours til the kitchen sinks."

I remember face jokes.

I remember (finger hooked in mouth) "Lady would you please hang your umbrella somewhere else?"

I remember (pulling skin around eyes into "Oriental") "Mommy, you made my braids too tight!"

I remember (squashing face between hands) "Bus driver, will you please open the door?"

I remember little records with big holes (45's) and being able to carry a whole stack of them between a thumb and a finger.

I remember little yellow and red and green plastic children's records.

I remember chipped beef and gravy on toast.

I remember, in Boston, figuring out that a street with lots of antique shops on it might be good for cruising, and so I did a lot of walking up and down it ("window shopping") but, as I was afraid to look at anybody, I didn't do too well. (The understatement of the year) So home I'd go to my "handy work"; often aided by men's wear ads in back issues of "Playboy" magazine. Which was no easy feat, considering how carefully men's fashion photos avoid any hint of a body underneath. (Underwear ads the most infuriating of all) However, they did slip up every now and then. Like once I remember a very sexy two page bathing suit spread that got a lot of use. And (in reference to "no easy feat") that was long before it ever occurred to me that a little soap and water, or Vaseline, or something, might help.

I remember (early New York City days) seeing a man close off one side of his nostrils with a finger, while blowing snot out of the other nostril onto the street. (Shocking)

121

I remember seeing an old lady pee in a subway car recently and it wasn't shocking at all, I'm sorry to say. One *does* learn to draw blanks: a compliment to nothing.

I remember French bikinis.

I remember DDT.

I remember nothing to say when someone tells you that your fly is unzipped.

I remember lighting the filter end of a cigarette when you want to appear "cool."

I remember, at parties, after you've said all you can think of to say to a person—but there you both stand.

I remember trying to have a conversation with someone once with a hair sticking out of his nose.

I remember a lot of giggling and note-passing in the balcony at church.

I remember starched dress shirt collars.

I remember when my arms were always too long for my shirts. Or else the neck was gigantic.

I remember the very thin pages and red edges of hymn books.

I remember the noisy mass flipping of pages when the next hymn is announced.

I remember when all heads are bowed in prayer, looking around a lot.

I remember, when it's all over, very swirly organ music to exit with.

I remember a lot of standing around and talking outside on the steps afterwards.

I remember empty Sunday afternoons of feeling somehow all "empty" inside.

I remember a big Sunday lunch, a light Sunday night dinner, and in the morning—"school."

I remember Monday mornings. And Friday afternoons.

I remember Saturdays.

I remember the washing machine and the vacuum cleaner going at the same time.

I remember, when one stops before the other, a moment of "fake" silence.

I remember "muscle magazines" nothing to do with building muscles.

I remember Roman column props. Tilted to one side sailor caps. Crude tattoos. Blank expressions. Suggestive G-string pouch shadows. And big flat feet.

I remember (in color) *very* pink skin and *very* orange skin.

I remember trying not to look lonely in restaurants alone.

I remember the several rather unusual ways "Pouilly-Fuissé" has come out of my mouth, trying to order a bottle of wine in restaurants.

I remember, eating alone in restaurants, making a point of looking around a lot so people wouldn't think I was making a point of *not* looking around a lot.

I remember, eating out alone in restaurants, trying to look like I have a lot on my mind. (Primarily a matter of subtle mouth and eyebrow contortions)

I remember (too much wine) trying to leave a restaurant gracefully. Which is to say, in a series of relatively straight lines.

I remember over-tipping. And I still do.

I remember liking to impress sales clerks by paying no attention to price tags. And I still do.

I remember having a big crush on this guy, and fantasies of dropping everything and going away with him somewhere (like maybe sunny California) and starting a whole new life together. Only unfortunately, he didn't have a crush on me.

I remember fantasizing about being a super-stud and being able to shoot *enormous* loads. And (would you believe it?) (yes, you'll believe it) I still do.

I remember knowing what "c-a-n-d-y" meant long before I knew how to spell.

I remember: "What's your sign?"
"Pisces."
"I knew it!"

I remember blowing the white fuzz off dandelions after the petals are gone.

I remember making awful noises with a rose petal in my mouth, but the "how" of how to do it is something I don't remember.

I remember "bread and butter" when something in the street divides you from the person you're walking down the street with.

I remember "Last one to the corner's a rotten egg!"

I remember "Go to jail—pass go—do *not* collect $200."

I remember that George Washington Carver invented peanut butter.

I remember blowing up paper bags to pop.

I remember cartoon stars when someone gets hit over the head. And light bulbs for a bright idea.

I remember making up abstract foreign languages, which sounded totally convincing, to me.

I remember keeping a list of States visited.

I remember making a three-dimensional map of the United States with oatmeal and paste.

I remember spatter-painting autumn leaf silhouettes with a toothbrush and a piece of screen door wire.

I remember packing up toothbrushes and washcloths and Crayolas (etc.) into individual Red Cross boxes for underprivileged children overseas.

I remember how long a seemingly empty tube of toothpaste can go on and on and on.

I remember when someone grabs your arm with both hands twisting in opposite directions—an "Indian burn."

I remember, after eating ice cream too fast, a cold head rush.

I remember Creamsicles and Fudgesicles and Popsicles that broke (usually) in two.

I remember stealing pieces of candy from previously broken bags on supermarket shelves.

I remember that because someone else had already done the dirty work it made it to my mind "o.k."

I remember poking my finger into cellophane-wrapped blobs of meat impossible to imagine someone might actually eat.

I remember "Next time, you'll stay at home!" because I was always wanting this or that, and this or that was always too expensive, or not good for you, or something.

I remember bright orange jars of cheese spread. And tiny tins of pink deviled ham.

I remember how that "powdered cheese" you put on spaghetti smelled suspiciously like dirty feet to me.

I remember (Easter) drawing on white eggs with a white Crayola before dipping them.

I remember not very hard Easter egg hunts. And the ones that didn't get eaten soon enough got all gray-green inside. (To say nothing of smelling like shit!)

I remember the chocolate Easter bunny problem of where to start.

I remember some pretty fuzzy ideas as to what "Ground Hog Day" and "Leap Year" were. Or, for that matter, are.

I remember thinking that "S.O.S." meant something dirty.

I remember fantasies of finding notes in old bottles washed ashore.

I remember magic carpets and giant "genies" and trying to figure out what my three wishes would be.

I remember not understanding why Cinderella didn't just pack up and leave, if things were really all *that* bad.

I remember getting a car door slammed on my finger once, and how long it took for the pain to come.

I remember wondering if goats really *do* eat tin cans.

I remember the fear of "horror" coming out of my mouth as "whore," as indeed it quite often did.

I remember rocks you pick up outside that, once inside, you wonder why.

I remember hearing once about a boy who found a dead fly in his Coke and so the Coca-Cola company gave him a free case of Cokes.

I remember thinking how easy it would be to get a free case of Cokes by putting a dead fly in your Coke and I remember wondering why more people didn't do that.

I remember a girl with hair down to past her waist until she had to cut it off because it got so heavy her hairline was receding.

I remember red hands from falling down on gravel driveways.

I remember searching for something you *know* is there, but it isn't.

I remember infuriating finger cuts from pieces of paper.

I remember (ouch!) bare feet on hot summer sidewalks.

I remember once on T.V. news an egg being fried on the sidewalk as an example of just how hot the heat wave we were having really was.

I remember my mother talking about women who shouldn't wear slacks.

I remember taking baths with my brother Jim when we were very young, back to back.

I remember inching myself down into water that was too hot.

I remember the "tornado" way the last of the water has of swirling down the drain so noisily.

I remember stories about people getting electrocuted by talking on the telephone in the bathtub.

I remember telephone nooks built into walls. And "party lines."

I remember (recently!) getting blown while trying to carry on a normal telephone conversation, which, I must admit, was a big turn-on somehow.

I remember not very scary ghost stories, except for the dark they were told in.

I remember having a friend over-night, and lots of giggling after the lights are out. And seemingly long silences followed by "Are you asleep yet?" and, sometimes, some pretty serious discussions about God and Life.

I remember get-rich-quick schemes of selling hand-painted bridge tallies, inventing an umbrella hat, and renting myself out as an artist by the hour.

129

I remember my high school art teacher's rather dubious theory that the way to tell if a painting is any good or not is to turn it upside down.

I remember bird pictures from Mexico made out of real feathers, with hand-carved frames.

I remember picture windows with not much view except other picture windows.

I remember the rather severe angles of "Oriental" lamp shades.

I remember, up high, wallpaper borders.

I remember, when relatives come visit, a cot.

I remember (when relatives come visit) "getting away with murder."

I remember "good dishes" versus "everyday dishes."

I remember that a good way to get a "maybe" instead of a "no" is to ask for what you want in front of company.

I remember, in pajamas with feet, long acrobatic kisses in grown-up laps to prolong "bed" for as long as possible.

I remember being talked about as tho I wasn't there.

I remember once a grown-up lady pretending to pull off her thumb (a trick) and the next thing I knew my milk was all over the floor of a strange house.

I remember once at a Church dinner social having to sit right across from a lady who had no vocal chords and all she could do was make weird noises and I couldn't eat a bite.

I remember a cigar box out in the garage filled with odds and ends of just about everything, of which a broken green "pearlized" fountain pen stands out the most to me now.

I remember once secretly planting some watermelon seeds out in the backyard but nothing happened.

I remember unpopular dogs that were allowed to roam the neighborhood freely. And—"Don't forget to close the gate behind you!"

I remember wondering how turtles "do it."

I remember when, walking single file from class to class, getting out of line was pretty serious.

I remember pencil boxes with a little ruler and a little compass in a little drawer.

I remember diagramming sentences. And arithmetic cards, more than I remember arithmetic.

I remember, in bed in the dark, visions of our house catching fire during the night.

I remember, in the morning, my eyelashes glued together with "sleep."

I remember believing that you could get warts by touch-

ing frogs enough that I...Actually, I was such a big sissy I wouldn't have touched a frog anyway.

I remember trying to conjure up visions in my head of a physical god without very much luck other than "very old" and "very white."

I remember waiting for a certain piece of mail to arrive with almost total faith that if I *really* wished hard enough it would come that day.

I remember, after reading a gay porn novel about a boy who "practiced" with a cucumber so he could learn to enjoy being fucked, trying to casually buy a vibrator at the drugstore: "Two packs of Tareytons, please. And one of those." And then I remember how long it took me to get batteries for it. And then I remember using it a few times, and how more ridiculous than sexy it all seemed. And so that was pretty much that. (Almost) Until one night, feeling "far out" (for me) I used it on a friend with a rather rewarding sense of power.

I remember very wholesome fantasies of being madly in love with a young blonde "hippie" boy, and of our living together out in the country, riding around alot naked on horses, pausing now and then to make love out in the sun, in the middle of the big beautiful fields.

I remember "being all alone with J. J. Mitchell at a ski lodge out-of-season" fantasies, which worked out just fine.

I remember, just before coming, fantasy close-up visions of big pink cocks being yanked out of bulging underwear, anxious to be serviced, and spurting hot mountains of white into

132

my mouth, nose deeply buried in wiry masses of dank pubic hairs.

I remember in the morning (*real life*) "hickies."

I remember much contemplation over what would be the most practical and considerate way to commit suicide, should the occasion happen to arise, with the usual conclusion that to just "disappear" out into the ocean would probably be best: with, however, some frustration over the possibility of getting washed ashore and scaring some poor little kid with a bucket half to death.

I remember (Oklahoma) boring annual Indian pageants of many feathers, and much stomping.

I remember the still mysterious to me association of western music with greasy eggs in a diner on a Sunday morning.

I remember "double dating," and "going dutch," and autographing broken leg casts.

I remember "close dancing," with arms dangling straight down.

I remember red rubber coin purses that opened like a pair of lips, with a squeeze.

I remember a boy who could swig down a Coke in one big gulp, followed by a long loud belch.

I remember, just outside the city limits, firecracker booths.

I remember (basketball) total frustration over how to "dribble."

I remember finding it very mysterious that ballet dancers didn't break their toes off, doing what they do that way.

I remember record stores with glass windowed booths you could play records in before you bought them, or didn't.

I remember, in dime stores, "bronze" horses in varying sizes from small to quite large, with keychain-like reins.

I remember, at the circus, kewpie dolls on sticks smothered in feathers, and how quickly their faces got full of dents.

I remember "pick-up sticks," "tiddly-winks," "fifty-two pick-up" and "war."

I remember dangerous BB gun stories about kids losing eyeballs.

I remember being more than a bit disappointed over all the fluffy gray stuff with tiny red specks I discovered inside an old teddy bear's stomach once.

I remember turning around and around real fast until you can't stand up.

I remember going on fly swatting sprees, and keeping a very accurate count of how many dead.

I remember crocheted dress-up gloves with only half fingers.

I remember "tupperware" parties.

I remember traveling salesmen jokes way over my head, which didn't keep me from finding them funny anyway.

I remember "knock-knock" jokes. And Polish jokes. And a "What's for dinner?" cannibal joke with a "Catholic soup!" reply.

I remember "spin the bottle" and "post office."

I remember dashes for dirty words in adult novels.

I remember, when a fart invades a room, trying to look like I didn't do it, even if, indeed, I *didn't*.

I remember the way a baby's hand has of folding itself around your finger, as tho forever.

I remember the different ways people have of not eating their toast crust.

I remember Dr. Brown fantasies of bright lights and silver instruments, and clinical "explorations" that develop into much hanky-panky on the examination table.

I remember Christine Keeler and the "Profumo Affair."

I remember stories about how L.B.J. got off on holding private conferences while on the john.

I remember the rumor that James Dean got off on bodily cigarette burns.

I remember fantasies of what I would say to a certain reviewer who gave me a really *mean* (to say nothing of stupid) review once, should we happen to meet at say a party or something.

I remember awkward elevator "moments."

I remember when both arms of your theater seat have elbows on them.

I remember making designs in the dark with a fast-moving lit cigarette.

I remember (spooky) when all of a sudden someone you know very well becomes momentarily a *total stranger*.

I remember (stoned) reaching out for a joint that isn't really being passed to you yet.

I remember (stoned) when the most profound thought in the world totally evaporates before you can find a pencil.

I remember (night) desperate (to say nothing of fruitless) flips through my address book.

I remember how silly it all seems in the morning (again).

I remember getting up at a certain hour every morning to walk down the street to pass a certain boy on his way to work. One morning I finally said hello to him and from then on we always said hello to each other. But that was as far as it went.

I remember taking Communion and how hard it was not to smile.

I remember smiling at bad news. (I still do sometimes) I can't help it. It just comes.

I remember that our church believed that when the Bible said wine it really meant grape juice. So at Communion we had grape juice. And round paper-thin white wafers that tasted very good. Like paper. Once I found a whole jar full of them in a filing cabinet in the choir room and I ate a lot. Eating a lot was not as good as eating just one.

I remember the exact moment, during Communion, that was the hardest to keep from smiling. It was when you had to stick out your tongue and the minister laid the white wafer on it.

I remember that one way to keep from smiling during Communion was to think real hard about something very boring. Like how airplane engines work. Or tree trunks.

I remember movies in school about kids that drink and take drugs and then they have a car wreck and one girl gets killed.

I remember one day in psychology class the teacher asked everyone who had regular bowel movements to raise their hand. I don't remember if I had regular bowel movements or not but I do remember that I raised my hand.

I remember changing my name to Bo Jainard for about one week.

I remember not being able to pronounce "mirror."

I remember wanting to change my name to Jacques Bernard.

I remember when I used to sign my paintings "By Joe."

I remember a dream of meeting a man made out of a very soft yellow cheese and when I went to shake his hand I just pulled his whole arm off.

BOOKS BY JOE BRAINARD

I Remember (Angel Hair, 1970).

Some Drawings of Some Notes to Myself (Siamese Banana, 1971).

Bolinas Journal (Big Sky, 1971).

Selected Writings (Kulchur Foundation, 1971).

I Remember More (Angel Hair, 1972).

The Banana Book (Siamese Banana, 1972).

The Cigarette Book (Siamese Banana, 1972).

Self-Portrait, with Anne Waldman (Siamese Banana, 1972).

More I Remember More (Angel Hair, 1973).

New Work (Black Sparrow, 1973).

I Remember Christmas (Museum of Modern Art, 1973).

THE AUTHOR

Joe Brainard was born in Salem, Arkansas in 1942 and grew up in Tulsa, Oklahoma. He moved to New York City in 1961. His paintings have been exhibited in numerous one-man and group shows, and are found in many private and museum collections.